Historic England

Cheshire

Paul Hurley

AMBERLEY

Acknowledgements

Thanks are due to all who have allowed me to use photos and postcards from their archives. Of course, as usual, thanks to my wife, Rose, for her patience during the writing of this book.

About the Author

Paul Hurley is a freelance writer and author, and a member of the Society of Authors. He is married and lives in Winsford, Cheshire, with his wife Rose. He has written a number of books: *Britain Invaded*, *Middlewich* (with Brian Curzon), *Northwich Through Time*, *Winsford Through Time*, *Villages of Mid Cheshire Through Time*, *Frodsham and Helsby Through Time*, *Nantwich Through Time*, *Chester Through Time* (with Len Morgan), *Middlewich & Holmes Chapel Through Time*, *Sandbach, Wheelock & District Through Time*, *Knutsford Through Time*, *Macclesfield Through Time*, *Cheshire Through Time*, *Northwich, Winsford & Middlewich Through Time*, *Chester in the 1950s*, *Chester in the 1960s*, *Villages of Mid Cheshire Through Time Revisited*, *Chester Pubs*, *Chester in 50 Buildings*, *Northwich Through the Ages*, *Brewing in Cheshire*, *Macclesfield History Tour*, *Knutsford History Tour*, *Chester History Tour*, *Nantwich History Tour*, *Northwich History Tour*, *Steam Nostalgia in the North of England* (with Phil Braithwaite), *Remembering Steam* (with Phil Braithwaite), and *The Changing Railways of Britain* (with Phil Braithwaite). www.paul-hurley.co.uk.

First published 2019

Amberley Publishing
The Hill, Stroud, Gloucestershire, GL5 4EP
www.amberley-books.com

Copyright © Paul Hurley, 2019

The right of Paul Hurley to be identified as the Author of this work has been asserted in accordance with the Copyright, Designs and Patents Act 1988.

The publisher is grateful to the staff at Historic England who gave the time to review this book.

All contents remain the responsibility of the publisher.

ISBN 978 1 4456 9179 4 (print)
ISBN 978 1 4456 9180 0 (ebook)

British Library Cataloguing in Publication Data.
A catalogue record for this book is available from the British Library.

Typesetting by Aura Technology and Software Services, India. Printed in Great Britain.

Contents

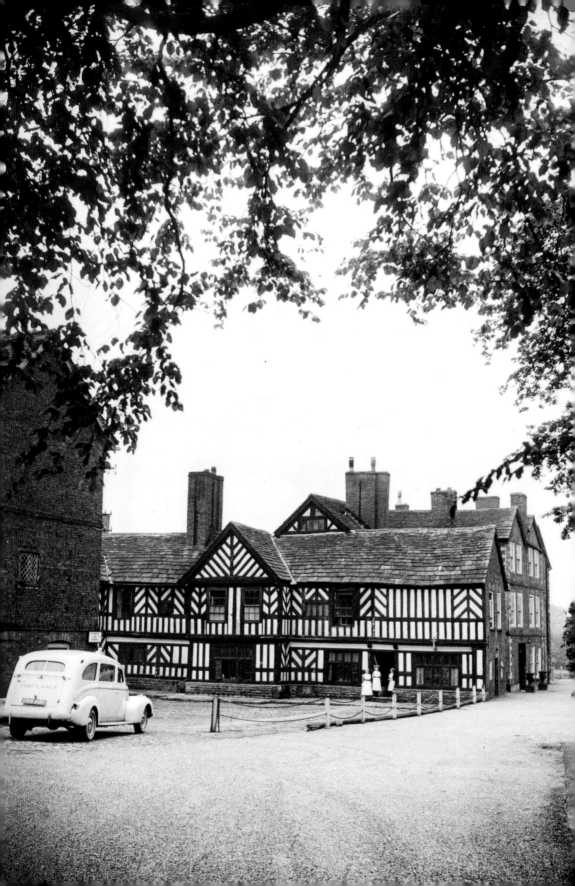

Introduction

Most of Cheshire is flat, hence the name 'the Cheshire Plain', but in Disley and Macclesfield, featured at the beginning of this book, the land is far from flat, and the Cheshire Plain gives way to the Cheshire Peak District as the road passes through the windswept moor on the way to Buxton. This is an affluent part of the county, and of the country for that matter: Wilmslow, Alderley Edge and Prestbury have been given the sobriquet 'Cheshire's Golden Triangle'. Villages and towns in the area, such as Mottram St Andrew and Knutsford, slip off the tongues of wealthy celebrities and football stars.

Cheshire is not only a panorama of bewitching beauty today, but it also drifts through the history of Britain like a golden thread. One of Prince Charles's titles is Earl of Chester because down the ages Chester has been a very important city. It was once called Deva by the Romans who settled there and fortified it, and there were the battles with the Welsh who attacked it from across the border. It is Britain's only remaining walled city in which the walls are intact, and they make a very pleasant walk for the many tourists who seek its antiquity. The same can be said for the ancient Rows, where there are shops on two levels dating from as far back as the eleventh century in some cases. Sailing ships once came up from the River Mersey to moor on what is now the famous Roodee. Racehorses have replaced ships at this popular destination; the oldest racecourse in Britain. Then there is Knutsford, home to the famous author Elizabeth Gaskell and a town with the sole right to append the prefix 'royal' to the name of its May Day celebrations; Lower Peover, where Generals Patton and Eisenhower planned D-Day; and Cheshire can certainly hold its own in the chocolate-box village stakes, with so many worthy of a visit that there are too many to mention here.

Cheshire once reached out and encompassed Birkenhead and every town on the west side of the Mersey. Nowadays most of the Wirral comes under Merseyside. Most of Cheshire's losses were to Greater Manchester: Stockport, Hazel Grove, Altrincham, Sale and Stalybridge have been dragged away to become part of the great conurbation. Cheshire has gained Widnes and Warrington though, and Disley is still in the county.

This book looks at the county as it was after the changes that came in 1974, when the centre of the county moved from Bostock and when so many pretty Cheshire villages became part of two of Britain's biggest cities. Older residents still refer to their address as Cheshire, as in Stockport or Birkenhead, and not their correct title of Greater Manchester and Merseyside. The River Mersey formed a natural separation for Liverpool and Cheshire, but far-flung Cheshire villages like Dukinfield, Hyde and Romiley suddenly moved into Greater Manchester. But Cheshire can still be enjoyed as it is now – a special place and a great area to live.

Macclesfield and Surrounds

Disley was one of the few villages that remained in Cheshire after amalgamation – some say that this was due to the insistence of the residents. The quickest way to get to the village is to travel through parts of Greater Manchester. The other more arduous way is to travel across the hills from Macclesfield.

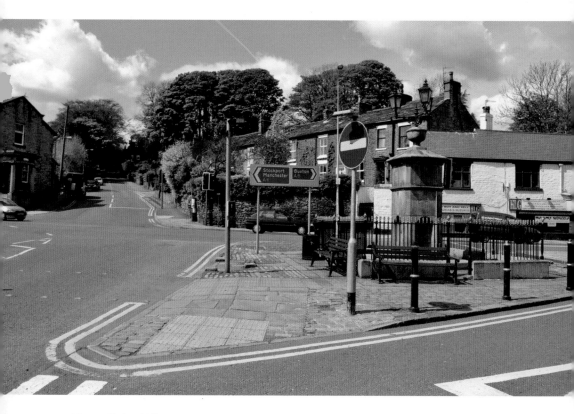

Above: Disley Village
Disley's Anglo-Saxon name was Dystiglegh, aptly meaning 'windy settlement', being on the border of Derbyshire and Greater Manchester. In 2008 a referendum was held asking if the residents wanted to remain in the new Cheshire East Council or jump over to the metropolitan borough of Stockport or Buxton High Peak. There was an overwhelming vote to remain in Cheshire East. (Author)

Opposite above: Disley Fountain Square
Dylan Thomas and his wife Caitlin visited the Disley home of the famous historian A. J. P. Taylor and although Margaret Taylor liked him, her husband did not. Thomas was a very heavy drinker – up to 20 pints of beer a day. They returned to the Taylor home in 1946 destitute and were allowed to live in the summerhouse in the garden. Two years later Margaret Taylor purchased a house for Thomas. This was the Boathouse at Laugharne in Carmarthenshire where, in the garden shed, *Under Milk Wood* was written. (Author)

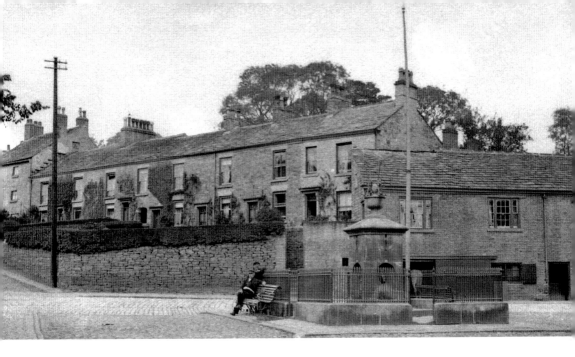

Below: Macclesfield Town Hall

Macclesfield is an ancient Cheshire town that stands beneath the sprawling and beautiful Peak District, the furthest outpost before taking the road into Derbyshire. Many years ago it entered the Industrial Revolution in a more genteel manner, perhaps, by becoming a silk town. Here all manner of silk items were manufactured, such as the narrowest ribbons and the best of silks and satins.

Macclesfield town centre is dominated by the impressive Town Hall. The main building with its Ionic columns was built between 1823 and 1824. It was designed in Greek Revival style by the architect Francis Goodwin. At this time the front, with similar Ionic columns, was built pointing west towards the church. In 1869–71 it was extended in a similar design by James Stevens, at this time building the new front with pillars facing Chestergate. (Author)

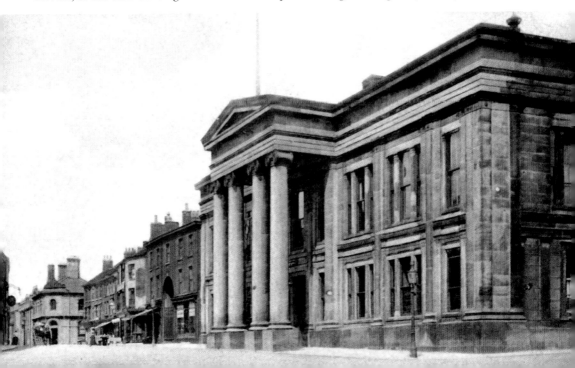

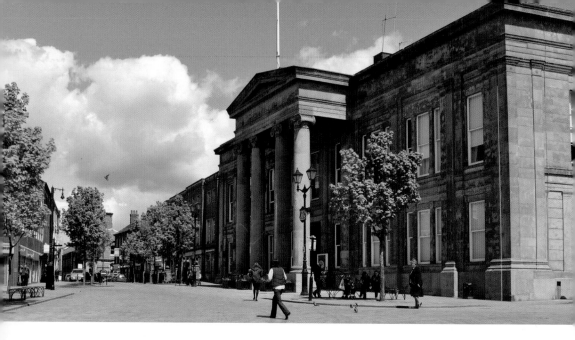

Macclesfield Town Hall
The Town Hall has a large assembly room containing six Ionic columns running along each side. Originally beneath this there was a butter and corn market. It also housed the Macclesfield Borough Police Headquarters when the town had its own chief constable and borough police force. The door to the old borough police station can be found at the side of the building by St Michael's Church. The building was further extended in 1991–92. (Author)

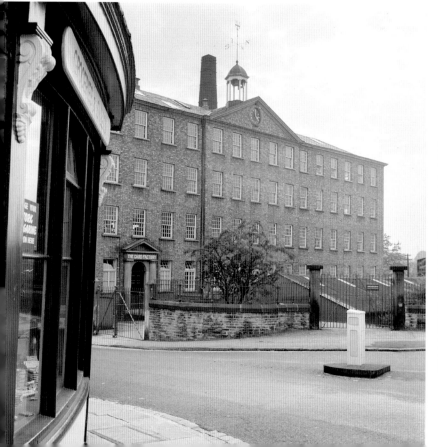

Regency Mill
Here is an example of one of the many highly attractive old mill buildings that still adorn the streets of Macclesfield. Like this one, Regency Mill, many are silk mills. This is located at the junction of Chester Road and Oxford Road. (Historic England Archive)

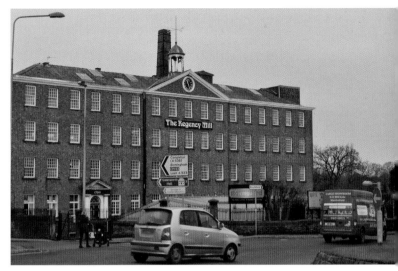

Regency Mill
The mill is still there and is a beautiful building although it is now used for other industries. It was built in around 1820, but the carving above the door shows the date '1790'. It was an integrated site that included silk manufacture, throwing, dying and weaving. The original occupiers of the silk mill were Hapgood and Parker. It was later converted to the manufacture of greeting cards and became known as the 'Card Factory'. (Author)

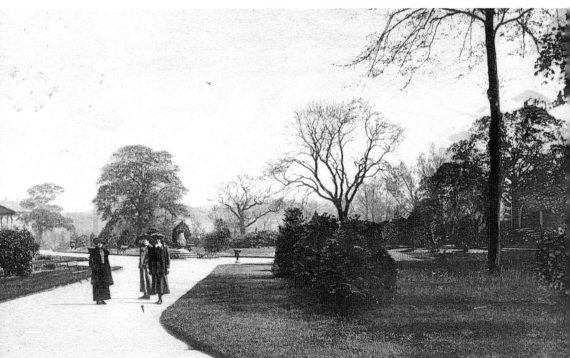

Victoria Park
Victoria Park was opened in 1894, not long before (the girls' school) King's School over the road. In addition to a bowling green the park also has a bandstand, aviary, lawns and flower gardens. It stands on land that once had a large house on it, situated on the site of what is now the girls' school. The house was demolished to build the school, and the land for the park was given by the Brocklehurst family, amounting to 13 acres. There is a monument within the park thanking Francis Dicken Brocklehurst for his generosity. (Historic England Archive)

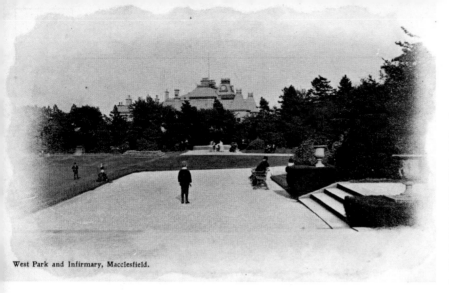

West Park and Infirmary, Macclesfield.

West Park
A view of West Park looking towards the infirmary. The park was built in 1854 and boasts one of the largest bowling greens in the country. (Historic England Archive)

West Park Hospital, Prestbury Road

Built originally as an institution and workhouse from 1843 to 1845, it was designed by the firm of Scott & Moffatt of Spring Gardens, London. Scott went on to be the famous architect Sir Gilbert Scott. The new workhouse could house 500 inmates and replaced one that was no longer fit for purpose. The sexes could be separated, as could the able-bodied, sane and 'imbecile'. Wives and husbands were split up, as were both mothers and fathers from their children. In 1929 its workhouse duties were over, and from then until 1947 it became the West Park Hospital. From 1949 to 1983 it was Macclesfield Hospital, West Park Branch, after which it became and remains Macclesfield District General Hospital, West Park Branch. (© Crown copyright. Historic England Archive)

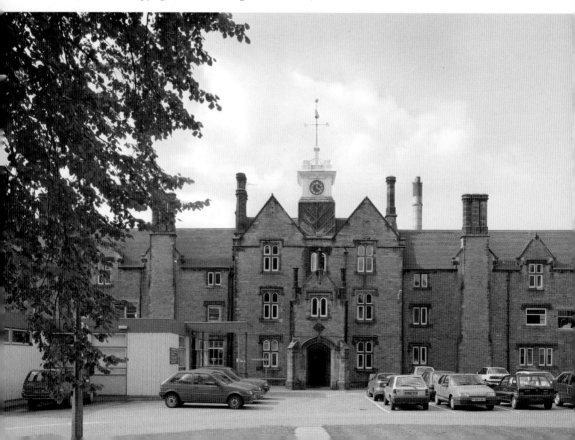

Silk Weavers' Cottages

These weavers' cottages are on the corner of Chatham Street and Great King Street. Macclesfield was the end of the Silk Road from China and as such was involved in the weaving of silk and the manufacture of silk products. These rows of terraced houses were called 'Garret Houses' and were usually three storeys, with the top one being the workshops – sometimes the workshop would stretch along a row of terraced houses. Many similar dwellings can be found in Macclesfield and elsewhere in Cheshire. (Historic England Archive)

Macclesfield Canal

The Macclesfield Canal was built by Thomas Telford and opened in 1831. It was built to connect with the Peak Forest Canal at Marple and the Trent & Mersey at Talke in Staffordshire. This was one of the later canals, having been built not that long before the railways arrived. The Macclesfield branch of the Manchester & Birmingham Railway was completed less than twenty years after the canal was opened. The heyday of the canal network was already in decline when Macclesfield's canal was built. (Historic England Archive)

Arighi Bianchi

Arighi Bianchi is a long-established furniture store in Macclesfield. It was founded in 1854 by Italian immigrants Antonio Arighi and Antonio Bianchi. Mr Arighi was the first to make the long journey from the silk-weaving town of Casnate on the shores of Lake Como. His long journey brought him to Macclesfield where he started to make clocks and barometers. This business was both successful and lucrative, and soon he was joined by Antonio Bianchi, already a successful master craftsman from the same village. Together they created Arighi Bianchi, a bespoke cabinetmaking business that used what Macclesfield was already famous for – silk and fine fabrics. It was in 1883 that they purchased the current site and had this quite unusual and beautiful shop built. It was modelled on the Crystal Palace in London, which dated from 1851. (Historic England Archive)

Prestbury

It must be stated that Prestbury, as well as being a quintessential English village, is also one of the most affluent in the country. It is the home of wealthy footballers, celebrities and business people. (Author)

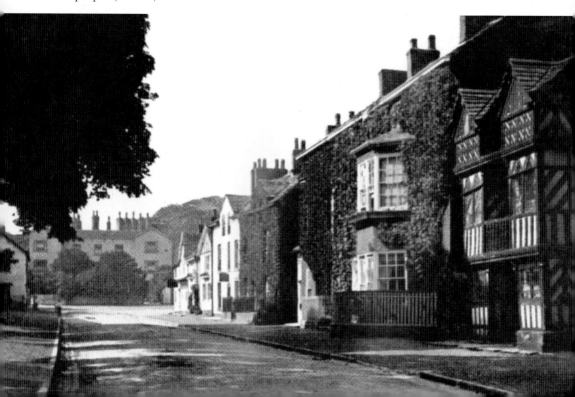

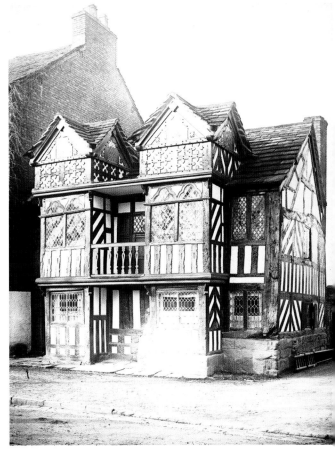

Right and below: The Priest's House, Prestbury
This ancient black and white bank building dates from around 1580 and was the residence of the vicar of the parish across the road. There is a plaque on the wall that tells us that during the Commonwealth the church was closed and the vicar preached from the balcony. This balcony was also used as a pulpit during periods of plague and 'sweating sickness'. It was opened as a bank in the early 1920s and serves that purpose today. (Historic England Archive)

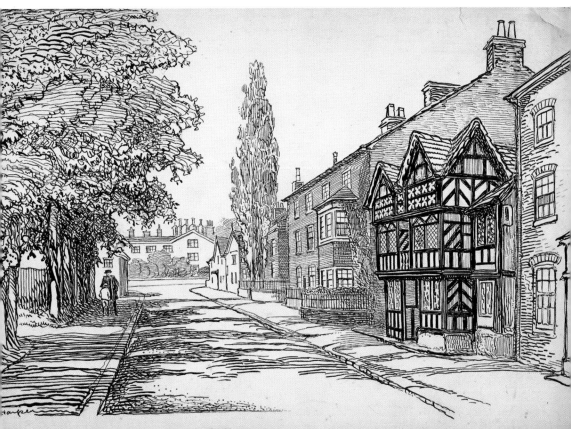

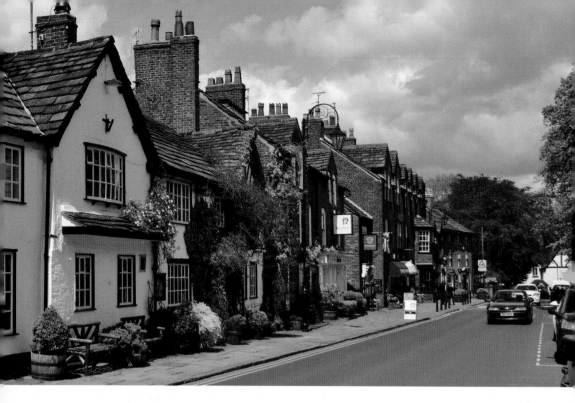

The Black Boy Inn, High Street, Prestbury

Here we look down the High Street, past The Legh Arms on the left. The Black Boy Inn dates from around 1580 and was to be called the Saracen's Head. An itinerant painter was to paint the Saracen's Head name board, but due to a mix-up in translation he painted a black boy on the board. The pub then became known as The Black Boy or Blackamoor's Head. In 1605 it was known as The Legh Arms after the landowners, the Leghs of Adlington Hall, and in 1900 it was The Black Boy Inn. The politically incorrect name has now been removed as far as the pub is concerned, but the adjoining restaurant still bears the name. It is now a very attractive pub and restaurant with accommodation. (Author)

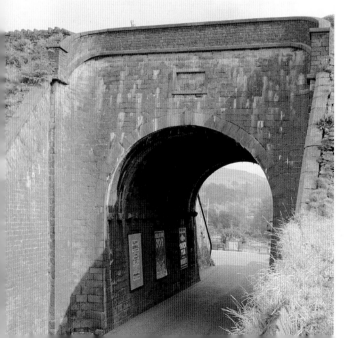

Bollington Aqueduct
Heading towards nearby Bollington we have another look at the Macclesfield Canal, which was built in 1826. (Historic England Archive)

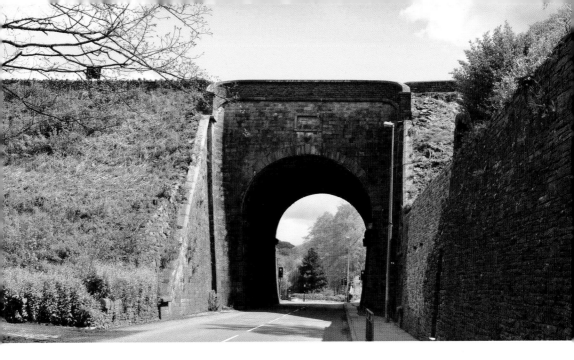

Above: Bollington Aqueduct
Bollington had two aqueducts, this one being the largest. It is very popular and busy, and is now part of the Cheshire Ring. (Author)

Below: Palmerston Street, Bollington
Palmerston Street is named after Lord Palmerston, who was prime minister in 1855, around the time that most of the buildings there were erected. The canal will have been a catalyst for the buildings around it. Palmerston Street was always a busy shopping street, and in the 1930s the Empire picture house was here. In the old photograph we can see Bollington's post office on the left, now a private house. (Author)

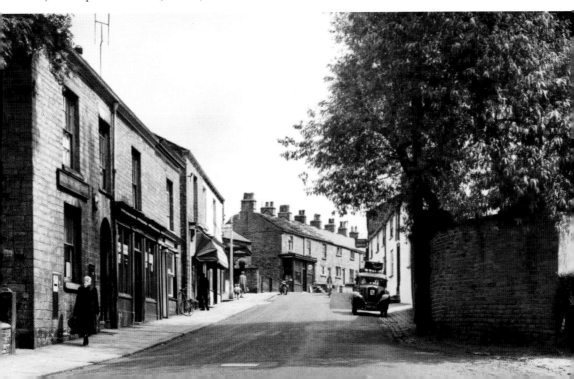

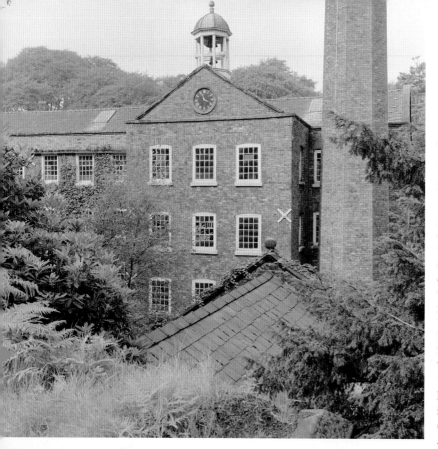

Quarry Bank Mill, Styal
This mill in Styal, here showing a pedimented section with a cupola, was built in 1784 and is one of the best of the preserved textile mills. It is also a museum of the cotton industry and was made famous in the 2013 series *The Mill*. The business was started by Samuel Greg. When he retired in 1832, it was the largest such business in Great Britain. (Historic England Archive)

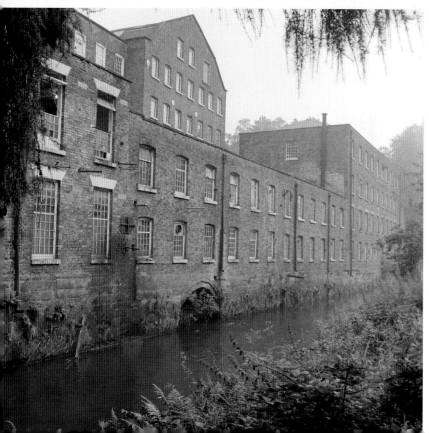

Quarry Bank, Styal
In 1939 the mill and its estate were donated to the National Trust by Alexander Carlton Greg, and the mill was opened to the public. The mill continued to produce cotton products until 1959. The National Trust now control the mill and grounds, which have become a very popular tourist destination. (Historic England Archive)

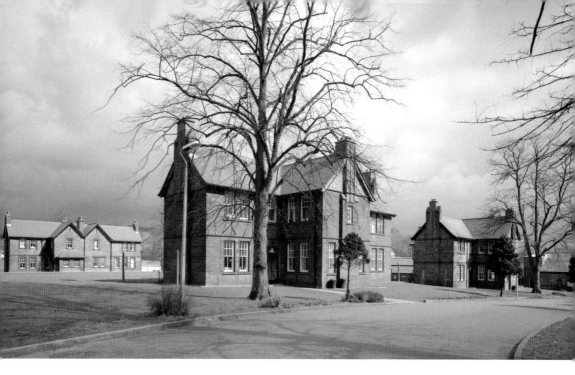

HMP and YOI Styal

The main prison buildings were originally built as an orphanage during the 1890s, and it remained as such until it was closed in 1956. Six years later it reopened as a women's prison and female prisoners from Strangeways in Manchester were transferred to it. From 1983 young offenders were admitted and then in 1999 a wing was added to accommodate unsentenced female prisoners following the closure of Risley Remand Centre at Warrington. (© Crown copyright. Historic England Archive)

HMP and YOI Styal

In January 2015 a twenty-five-bed unit was opened, and two months later the chapel was converted to a restaurant called The Clink. This enabled female prisoners to gain experience before release. Here we see a workroom for the prisoners. (© Crown copyright. Historic England Archive)

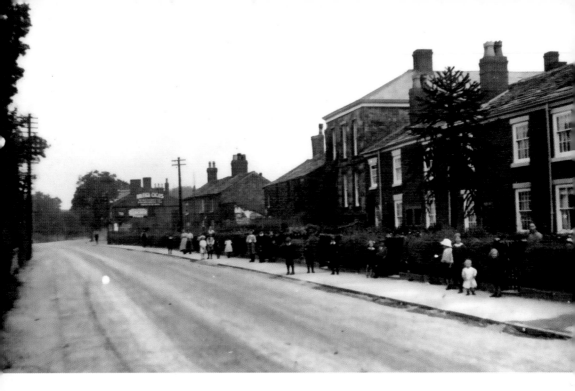

Above: Midway, Poynton
Situated between Macclesfield and Stockport, the area of Midway is in the village of Poynton. The town became heavily involved in all businesses to do with clothing, silk and affiliated industries. It was also a mining town, with mines owned by the Poynton and Worth collieries that boasted very good and profuse coal seams. (Author)

Below: Midway, Poynton
Modern Poynton has an intricate traffic system with mini-roundabouts set out in attractive coloured stone. (Author)

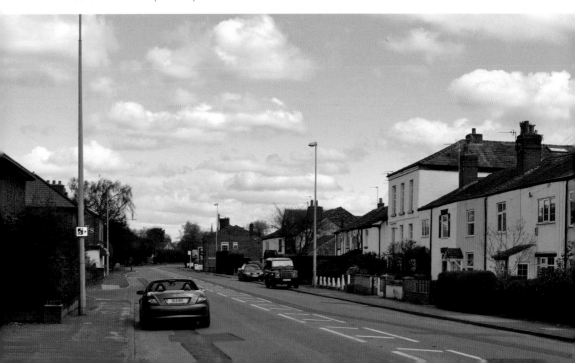

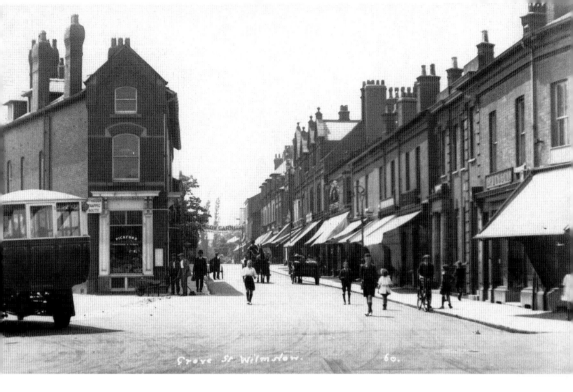

Above: Grove Street, Wilmslow
This old photograph dates to around the 1920s, although it could have been a little earlier, and it's likely that the bus with the solid tyres was old even then. The bus is just within Green Lane and at the time would have been outside the police station that was situated there. (Author)

Below: Modern Grove Street, Wilmslow
The police station was far too small and not fit for the purpose, having been built for very few officers. After the police station was relocated some years ago the building spent time as a pub called The Blue Lamp and was then demolished. As can be seen, little has changed in this view over the eighty-odd intervening years. (Author)

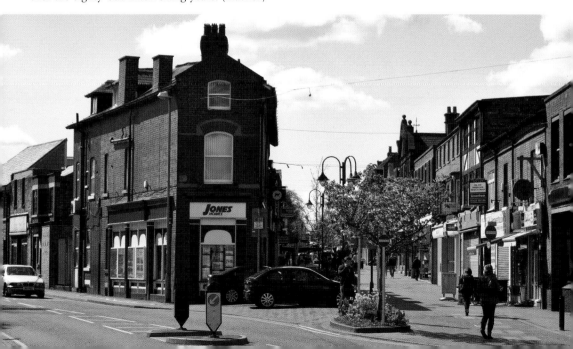

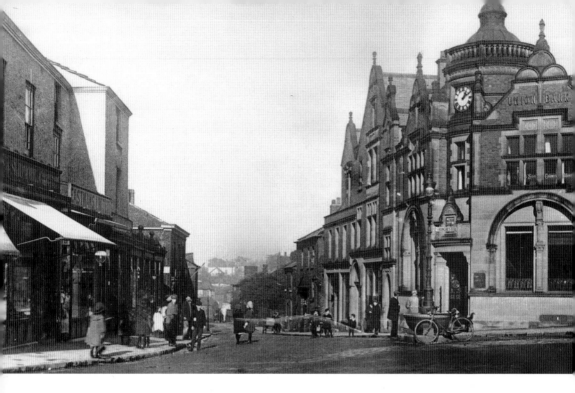

Above: Bank Square, Wilmslow
This image shows Eastman's butchers shop on the left and the Union Bank of Manchester opposite. Ahead is Church Street, which leads to Wilmslow Parish Church. (Author)

Below: Bank Square, Wilmslow
Since the old photograph was taken much rebuilding has taken place. The bank is still there but is now a public house and restaurant called The Boardroom. (Author)

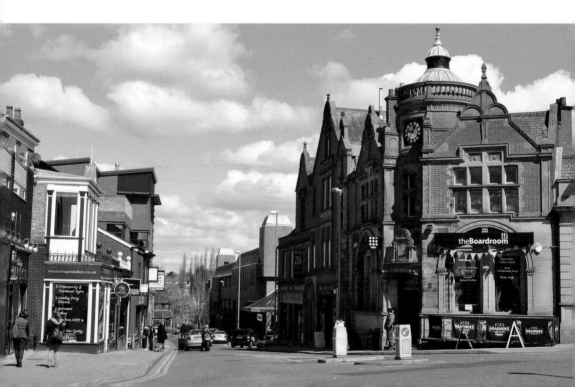

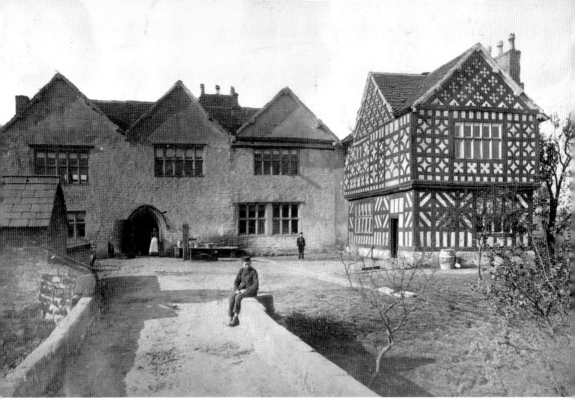

Above: Chorley Old Hall, Alderley Edge
Situated in Ryleys Lane, Alderley Edge, Chorley Old Hall is now the oldest inhabited country house in Cheshire. It was built in 1330, with a second range added in the sixteenth century. The hall has a moat and is Grade I listed. It was originally built by Robert de Chorley, but was recorded as being owned by the Davenport family by the mid-sixteenth century. It was that family who built the half-timbered house adjoining the main building. Acquired by the Stanley family in the same century, a bridge was built over the moat, and in the late eighteenth century the buildings were joined using brick. It was completely refurbished in 1915, and again in 1975. (Historic England Archive)

Right: Chorley Old Hall
An exterior view looking through an open doorway into the screens passage at Chorley Old Hall. This doorway, guarded by a West Highland terrier, is one of a pair that lies at either end of a former screens passage separating the hall of the medieval house from the service room. (Historic England Archive)

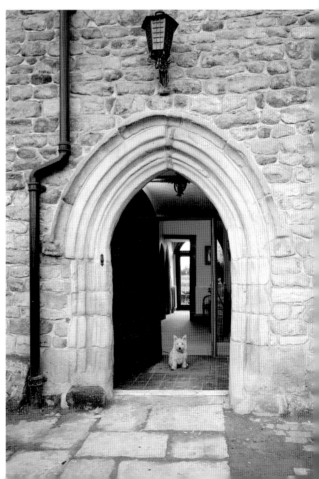

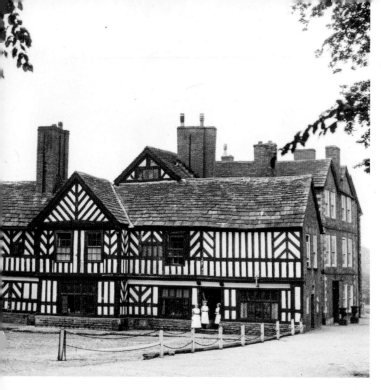

Left: Adlington Hall
Adlington Hall, near Macclesfield, was built between 1480 and 1505, starting with the Great Hall. The Legh family have lived in the house since the fourteenth century, and it has been improved and extended over the centuries. The hall was reduced and reconstructed in 1928. Also in that century, the extensive grounds were restored, as were the buildings that were part of them, including ten that are Grade II listed in their own right. The hall itself is Grade I listed. The home is open to the public at certain times and available for private hire. (Historic England Archive)

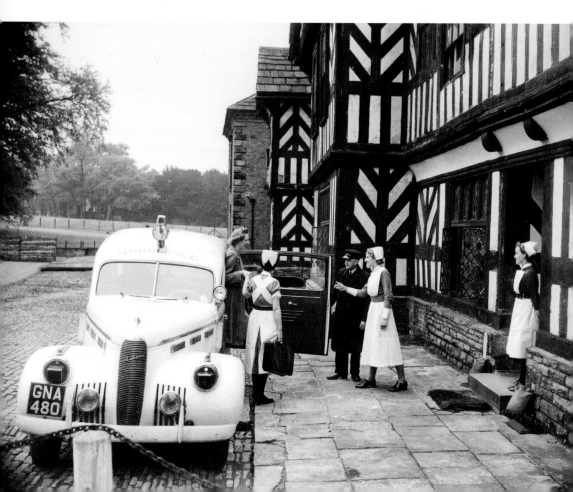

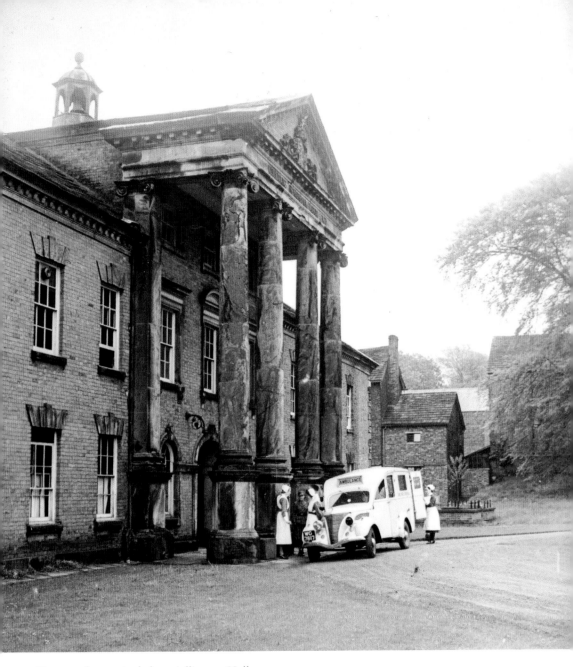

Above and opposite below: Adlington Hall

St Mary's Hospital was founded in 1790 as the Manchester and Salford Lying-in Hospital – in other words a maternity hospital. It is still serving the community well in a custom-built building in Oxford Road, Manchester. During the Second World War it was felt that the city centre locations of the Manchester hospitals were vulnerable to bombing. Annexes were located in other less vulnerable buildings.

One of these locations was Adlington Hall, where a maternity hospital dedicated to the wives of servicemen of all three services was sited. Below nursing staff are greeting a pregnant woman exiting an ambulance car at the hall. During the war, a total of 997 children were born there. (Historic England Archive)

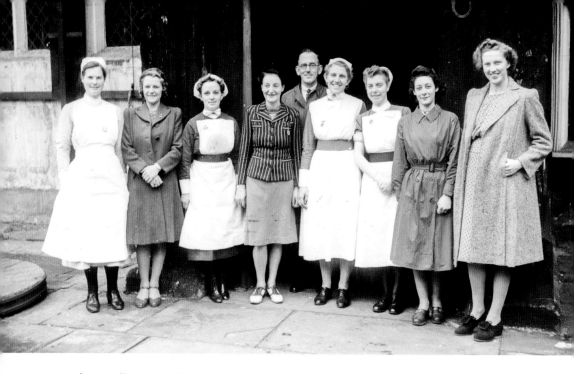

Above: Adlington Hall
Here staff and patients pose for a photograph outside Adlington Hall, St Mary's Services Maternity Hospital. (Historic England Archive)

Below: Maternity Hospital, Adlington Hall
Nurses, mothers and babies in part of one of the wards. (Historic England Archive)

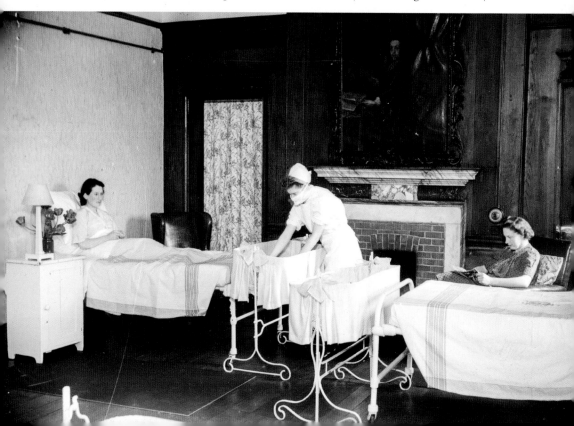

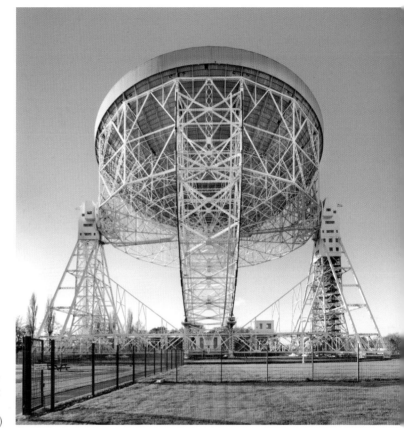

Lovell Telescope at Jodrell Bank
One of the most famous radio telescopes in Britain is situated at Lower Withington, near Macclesfield. In 1939 the Manchester University Department of Botany purchased three fields from the Legh family. The area was named Jodrell Bank after William Jauderell, whose family occupied a mansion that is now the Terra Nova School. In 1952 the site was extended by the purchase of a farm, and it was on this site that the telescope was built. Bernard Lovell had started his astrophysics work on the site in 1945 using equipment left over from the war.
(© Historic England Archive)

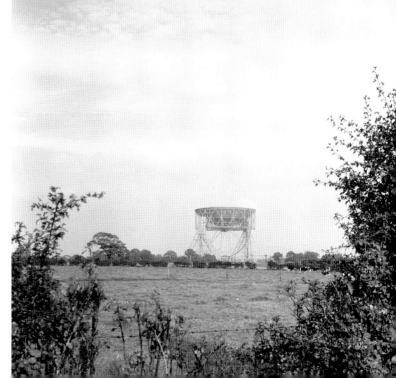

Jodrell Bank Radio Telescope
A view across fields towards the Lovell Telescope at Jodrell Bank in 1968. In 1957 the Lovell Telescope was built, using part of the gun turret mechanisms from the battleships HMS *Revenge* and *Royal Sovereign*, and at the time was the world's largest steerable dish radio telescope. It measured 76.2 metres (250 feet) in diameter. It is now the third largest in the world.
(© Historic England Archive)

Congleton Area

Above: Congleton High Street

Congleton is in the Domesday Book as Cogeltone, and is known by the locals as 'Bear Town'. This originated in the 1620s when bear-baiting and similar sports were enjoyed in the town. Unfortunately, the bear that they had was a bit weak and they wanted a strong one. Money was short, so they decided to use what that they had saved for a Bible to purchase a new bear instead. With a good strong bear they were soon able to repay the Bible fund. In the twentieth century, folk artist John Tame wrote the ditty, 'Congleton rare, Congleton rare, sold the Bible to buy a bear.' (Author)

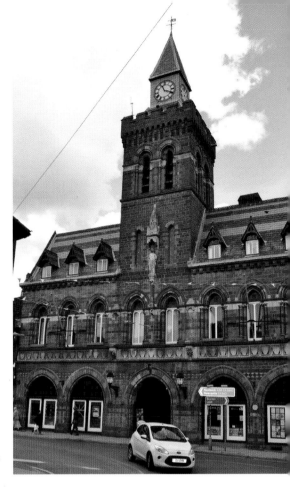

Right: Congleton Town Hall
The Town Hall was opened to the public in 1886, having been designed by Edward William Godwin to the design of his Northampton Town Hall. (Author)

Below: Nos 82–90 Mill Street
Another example of a garret house. These houses were built during the eighteenth and nineteenth centuries and were three storeys high, some with outside stairs. The houses are now Grade II listed. They were built for the handloom weavers who would use the upper floor to work. This floor, as can be seen in the photograph, was well lit by the large window area. Although not usually used for their original purposes, many houses are still standing in Mill Street and other areas in the town. (Historic England Archive)

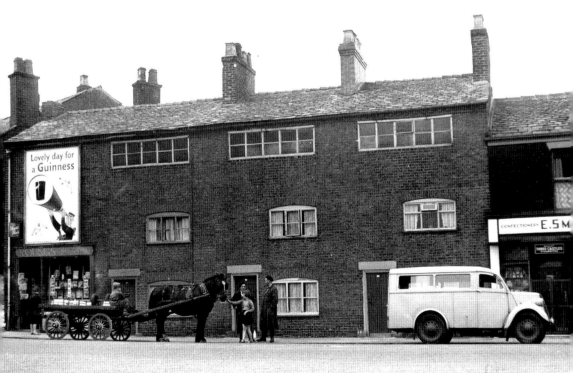

Above: Congleton Viaduct
The viaduct was designed by the engineer J. C. Forsyth for the North Staffordshire Railway, and it was opened in 1849. Twenty round arches are supported on rectangular piers. The larger part of this viaduct is in Congleton. (Historic England Archive)

Opposite above: Little Moreton Hall, Congleton Road, Odd Rode
Looking south through the porch leading from Little Moreton Hall's courtyard, this fantastic building is also called Old Moreton Hall. It is just over 4 miles from Congleton and is owned by the National Trust. It was built for wealthy landowner William Moreton in around 1505. It remained in his family until being transferred to the National Trust in 1938. The hall is Grade I listed and is open to the public from April to December. (Historic England Archive)

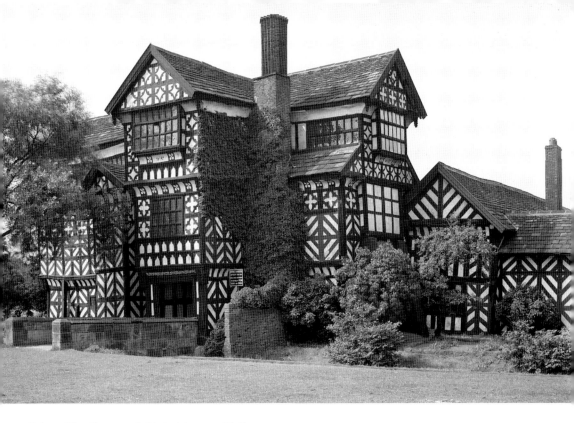

Below: The Courtyard, Little Moreton Hall
The hall was added to through the centuries. It is timber-framed throughout, except for three brick chimney breasts and some supportive brick buttressing that were added as required later. (Historic England Archive)

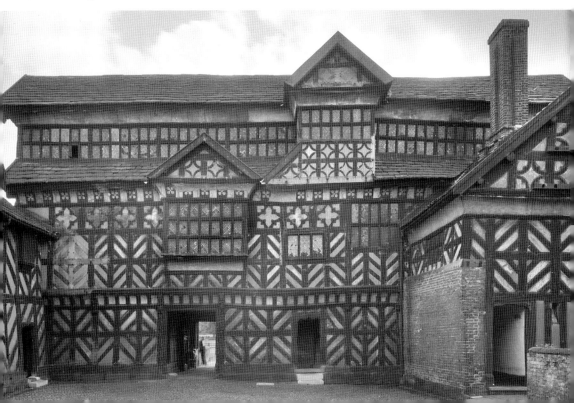

Mid Cheshire

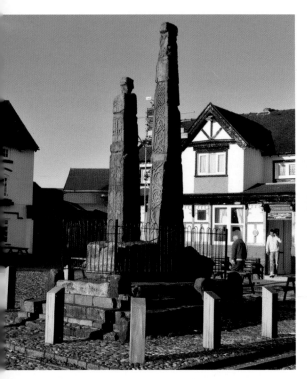 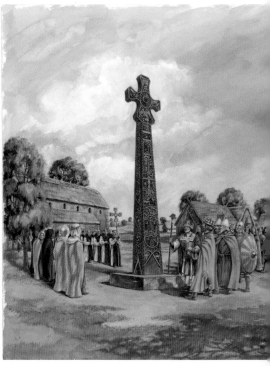

Above left: The Historic Sandbach Crosses
Much has been written about the two famous crosses or obelisks that stand in the old cobbled Market Square – some of it quite contradictory, but with treasures of such antiquity this is to be expected. What is known is that they are made from sandstone and covered in carvings depicting religious scenes. They are believed to have been erected around AD 653 when Christianity was brought to Mercia from Northumberland. They remained as religious icons for many centuries, but then they were in the shape of Saxon crosses. Two wooden replica Saxon crosses are on the common showing what such crosses looked like. (Author)

Above right: A Painting of the Crosses
In the seventeenth century, the crosses were smashed up in the Puritan fervour that was obsessed with false idols and the purity of uncluttered faith. The pieces were carried off across the county to such places as the Oulton Park estate and Tarporley. They were used as doorsteps and the like until the 1800s when the renowned historian Dr George Ormerod took the job in hand and sent his team out to scour the county to recover as many pieces as possible. In 1816, under his direction, they were erected on their current site. (© Historic England Archive)

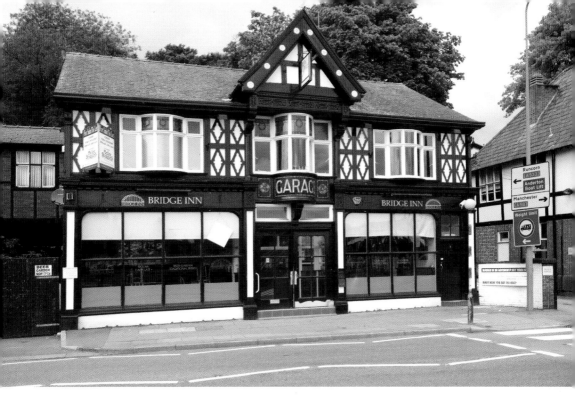

Bridge Inn, Northwich

Northwich, like many Cheshire towns, glows with beautiful black and white buildings. Some are ancient, but not very many, and certainly not in Northwich where brine subsidence destroyed many buildings. This building was erected in the 1920s and replaced the large structure that once stood there. It is now occupied by a locksmith, but it has a past life. It was opened as a garage in around 1920 – the word 'Garage' is still picked out in glass above the door. When a large Looker's car showroom and garage was built next door it became a carpet shop called Ardern's. It spent time as a café and JW's, then The Bridge bar and nightclub. (© Historic England Archive)

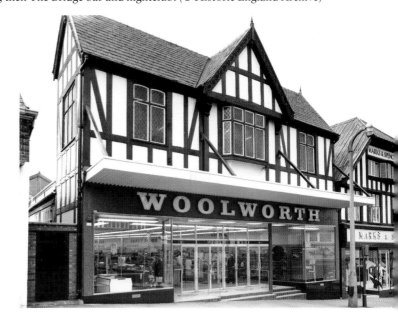

Woolworths, Northwich
A sadly missed shop from Nos 26–28 Witton Street, Northwich – F. W. Woolworth and Company. (Historic England Archive)

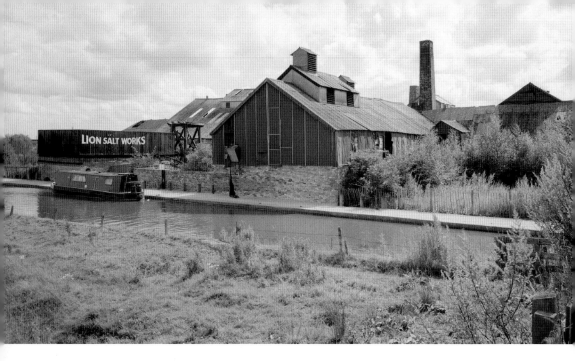

Above: Lion Salt Works, Ollershaw Lane, Marston
The Lion Salt Works, situated at the rear of the old Red Lion Inn (seen in the photograph), is now a living museum that is open to the public. The salt works closed in 1986. It was left derelict for a while, but is now an excellent visitor attraction. (© Crown copyright. Historic England Archive)

Below: Red Lion Inn
The old original Red Lion was situated near to the canal and had been trading since 1774. When Thompsons were expanding the Lion Salt Works around 1894 they demolished it. There were two cottages opposite the New Inn, now the Salt Barge, dating from 1877, and they were bought by Thompsons and converted into the new Red Lion. This then served the mine until 1940 when it was compulsorily closed. This building, with its Red Lion name board attached, is still there – it was incorporated into the mine offices. (© Historic England Archive)

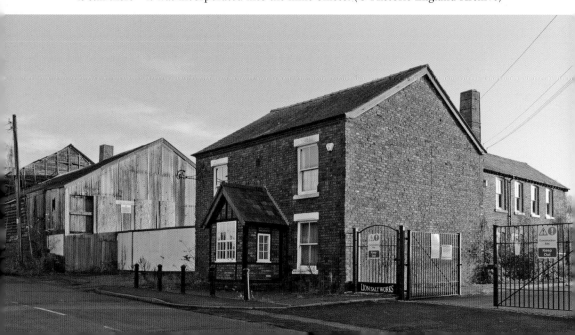

Salt Barge Public House
The Salt Barge public house is opposite the main entrance to the Lion Salt Works. It sits astride an area of land that is a honeycomb of underground mine workings. Long-disused mines with such names as Blackburns, New Alliance, Crystals, New Zealand, Nelson and Albert once existed here dredging up the salt from Triassic salt beds 40 metres below the surface. The only one left is the Lion Salt Works, which in 1928 was the last of the working open-pan salt mines. (© Historic England Archive)

The Anderton Lift
Here we have one of the wonders of the canals, or even 'Cathedral of the Canals'. The Anderton Boat Lift was built in 1874 to carry canal boats from the Trent & Mersey Canal to the River Weaver. There are only two working boat lifts in Britain, this one and the Falkirk Wheel in Scotland. (© Historic England Archive)

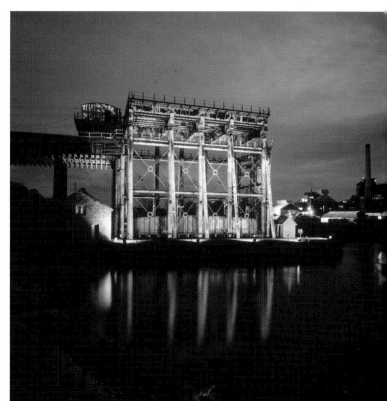

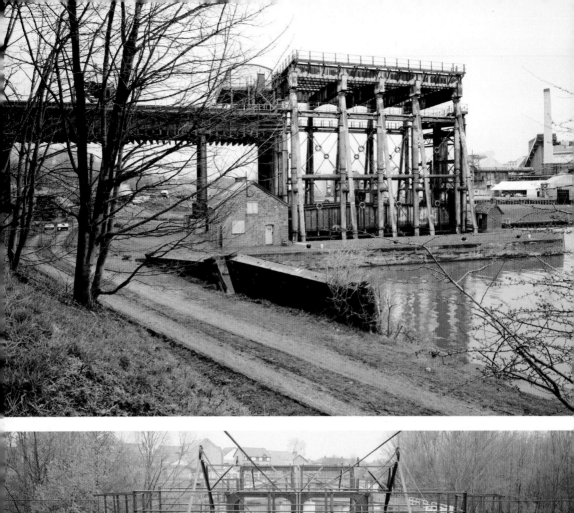

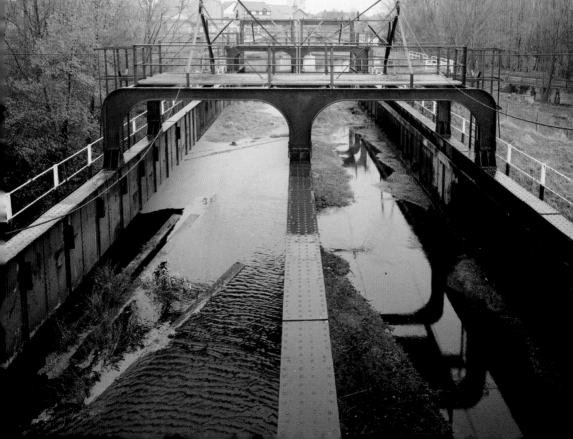

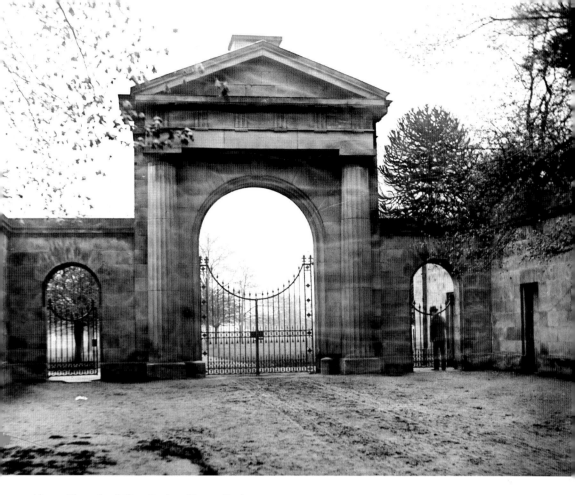

Above: Knutsford Gate Lodge, Tatton Park
This spectacular gate is situated at the northern end of King Street and includes the gatekeeper's lodge. The splendid Tatton Hall is through this arch, which over the years has welcomed royalty, dignitaries and some 60,000 troops who trained here as parachutists during the Second World War. (Historic England Archive)

Opposite above: The Anderton Boat Lift
Originally the Anderton Boat Lift worked using hydraulic rams with counterbalanced water-filled wrought-iron caissons to carry the boats, but after a period of neglect it is once again working and doing what it was built for, albeit by electric power. It also houses a visitor's centre. (© Historic England Archive)

Opposite below: Iron Caissons, Anderton
Canal craft would drive into the caissons and be conveyed from the Trent & Mersey Canal to the River Weaver below or in the opposite direction. (© Historic England Archive)

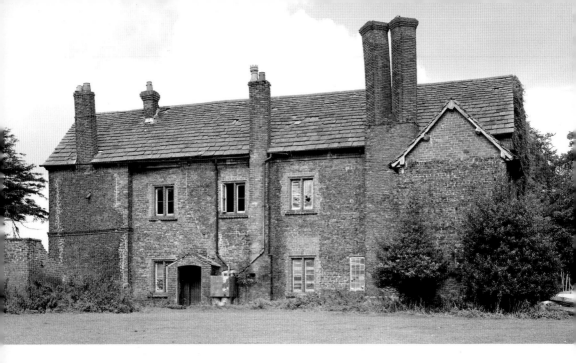

The Old Hall, Tatton
The Old Hall is a medieval building that stands near the former Tatton village. While this village no longer exists, humps and hollows show where houses once stood. The site is a Scheduled Ancient Monument and considered an area of significant historical and archaeological importance. The Old Hall survives as the oldest building in the park, having been built at the beginning of the fifteenth and sixteenth centuries. Tatton Hall itself stands in front of the Old Hall. It was built between 1758 and 1884 and is also a Grade I listed building and a beautiful mansion. The last resident was Maurice Egerton, who died in 1958, bequeathing the house and extensive lands to the National Trust. (Historic England Archive)

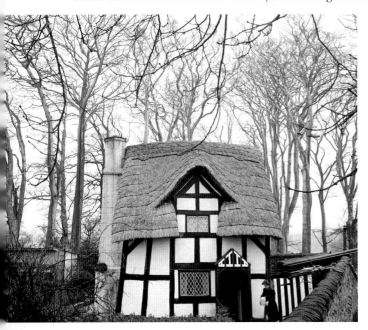

Parkwall Cottage, Rushton, Tarporley
A woman holding a jug outside a seventeenth-century timber-framed and thatched cottage with a large stone chimney breast. The cottage is now known as Sycamore Bank, Parkwall Cottage. (© Historic England Archive)

Corner Lodge, Forest Road, Portal Hall Estate, Tarporley

Portal is a large and imposing timber-framed country house in a Domestic Revival black and white style. It was only built in 1900 and was designed by Walter E. Tower. It is Grade II listed and was described by the architectural historian Nicholas Pevsner: 'It is a tour de force in an accurate but a scaled-up imitation of timber-framed mansions.' A nineteenth-century house called Portal Lodge was demolished to make way for the present one, which was the home of the Brooks family, who owned a successful calico printing works together with coal mines and quarries in Lancashire. The house is now the Macdonald Portal Hotel, which sits on a very popular golf course. The image is of the lodge to the estate. (© Crown copyright. Historic England Archive)

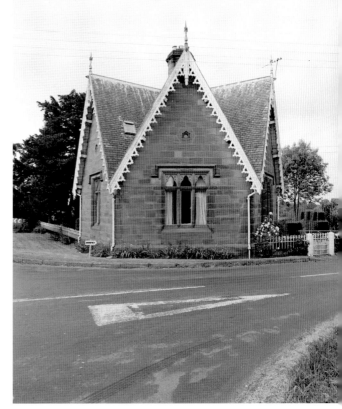

Oulton Hall, South Elevation

Oulton Hall, Little Budworth, no longer exists and should not be mistaken for the Oulton Hall that is now a hotel in the village of Oulton near Leeds. The Cheshire Oulton Hall was commissioned by John Egerton in 1715, believed to have been on the land once occupied by a Tudor house that had been destroyed by fire. The 'new' Oulton Hall was the home of the Egerton family. (Historic England Archive)

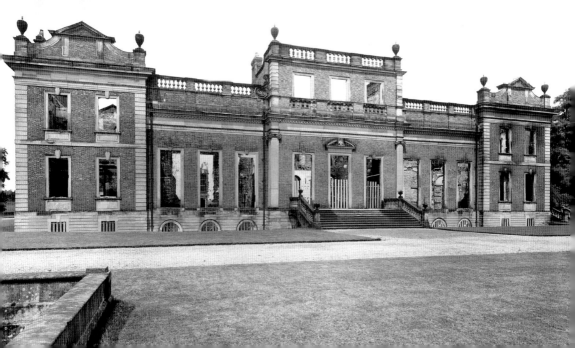

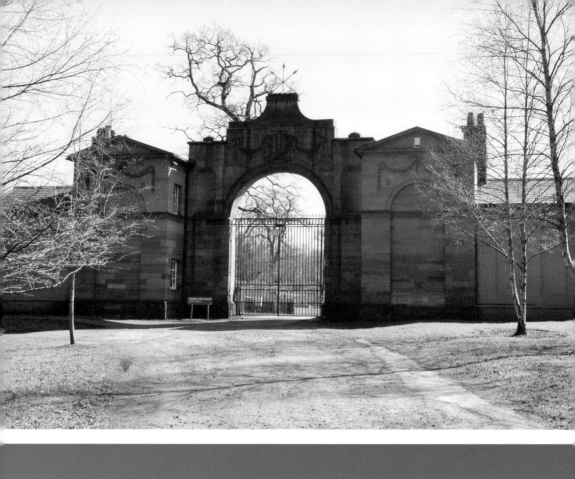
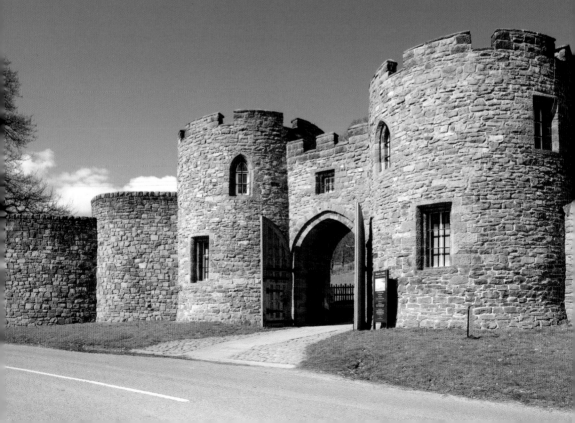

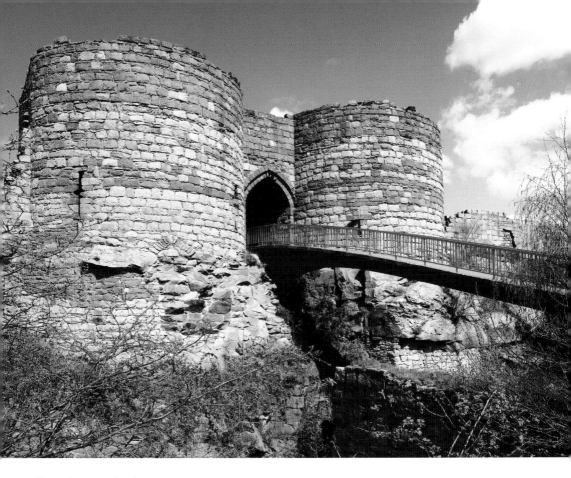

Above: Beeston Castle
Exterior view of the inner gatehouse, the inner ditch and the ramp at Beeston Castle. The castle is now open to the public. (© Historic England Archive)

Opposite above: Oulton Park Lodge and Gates
In 1773 the original gates were taken down and erected at St Oswald's Church, Malpas. They were replaced by the new gates seen here. These were designed by Joseph Turner in 1786 and are Grade II listed, as is the existing stable block and a monument in the park to John Francis Egerton of the Bengal Horse Regiment. On 14 February 1926, Oulton Hall burnt down, tragically killing six Little Budworth residents. In the Second World War, the US and other armies were stationed at Oulton Park Army Camp. General Patton spent time there, and during that war the remains of the hall were bombed. In 1953 Oulton Park Racing Circuit was opened, and it is now one of the country's top motor racing circuits. (Author)

Opposite below: Beeston Castle
Exterior view of Lord Tollemache's entrance building known as The Lodge at Beeston Castle. The castle, sitting on the site of what was an Iron Age hill fort, was built by Ranulf de Blonderville, 6th Earl of Chester, in the 1220s. In 1237, it was seized by Henry III and remained in royal ownership until the sixteenth century. It was then badly damaged during a long siege in the Civil War until the Royalists surrendered. The castle was then partly demolished on the orders of Cromwell. (© Historic England Archive)

Crewe and District

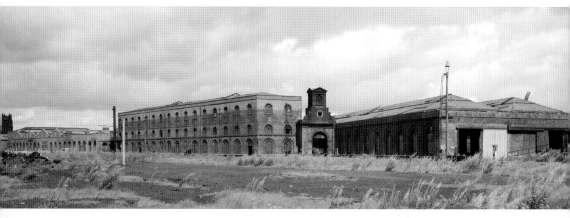

Locomotive Works, Forge Street
During its long life the huge Crewe Railway Works would build some 7,000 steam locomotives and employ 40,000 people. By 1957 the works were also building diesel locomotives, but in 2005 it had less than 1,000 employees. That figure has dropped even further now that the works are a shadow of their former self. Most of the works have now gone. (© Crown copyright. Historic England Archive)

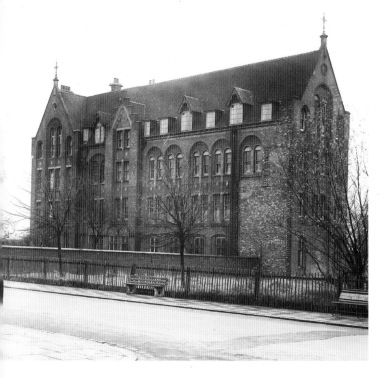

Ursuline Convent and School, Nantwich Road
This building dates from around 1910 and was designed by Philip Webb. It was built as an Ursuline convent – a French order of nuns. In the second half of the twentieth century, it became a police training college and vehicle maintenance facility for the Cheshire constabulary. A residential extension was erected for the students. When the new police headquarters was built in Winsford during 2002 the college and maintenance centre was transferred there. The old convent was closed, the new extension was demolished, and the main building converted into apartments with houses built in the grounds. It is seen here from Sommerville Street in 1915. (Historic England Archive)

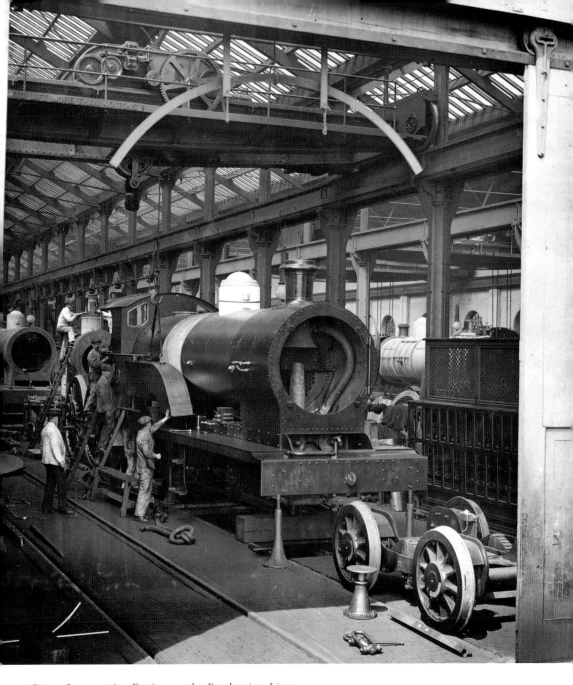

Steam Locomotive Engine on the Production Line
In 1840 the Grand Junction Railway (GJR) management realised that the railways were
more than a fad. It was decided that what it needed was a factory to manufacture railway
locomotives and all of the other paraphernalia for this new transport system. Edge Hill in
Liverpool already had a railway facility, including Edge Hill station, the oldest passenger
station in the world that is still in use today. It was from here that the Grand Junction
recruited their first members of staff. To house them 200 cottages were built in the small
village of Monks Coppenhall, soon to be incorporated into what was another small village –
Crewe. (Historic England Archive)

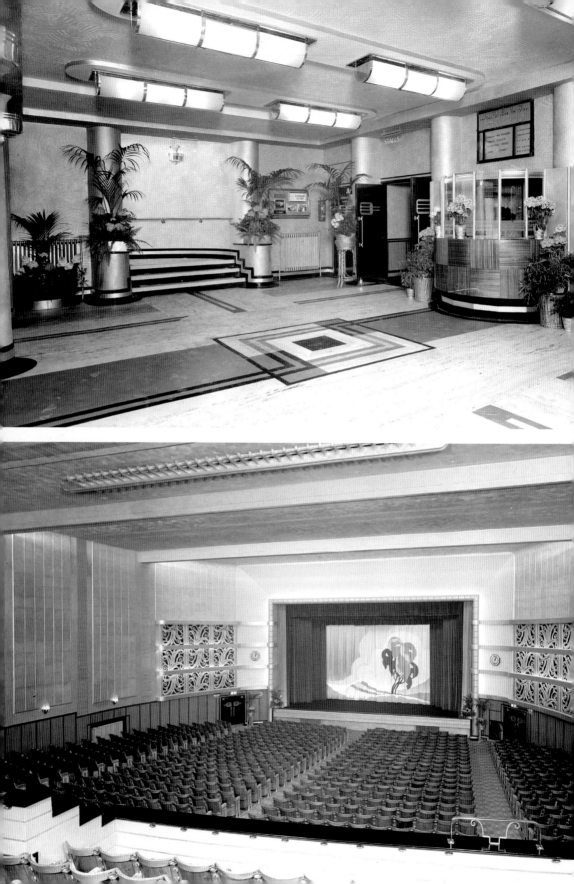

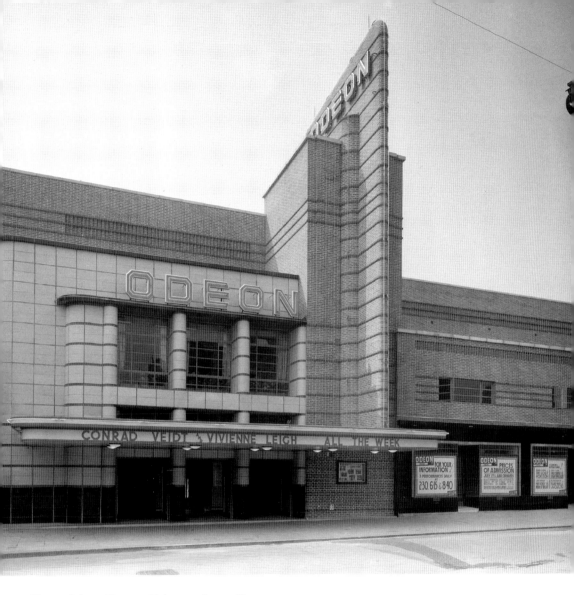

Above: Odeon Cinema, Delamere Street, Crewe
A view of the newly constructed cinema that was designed by the architect Budge Reid. It opened on 26 July 1937. In 1975, under new management, it was renamed the Focus Cinema. This was closed on 26 May 1983 and replaced by a McDonald's and other shops. (Historic England Archive)

Opposite above: Odeon Cinema, Delamere Street, Crewe
The foyer of the Odeon Cinema. (Historic England Archive)

Opposite below: Seating at the Odeon Cinema, Crewe
A modern multiplex cinema complex, also with the name Odeon, has been opened on the Phoenix Leisure Park, Dunwoody Way. (Historic England Archive)

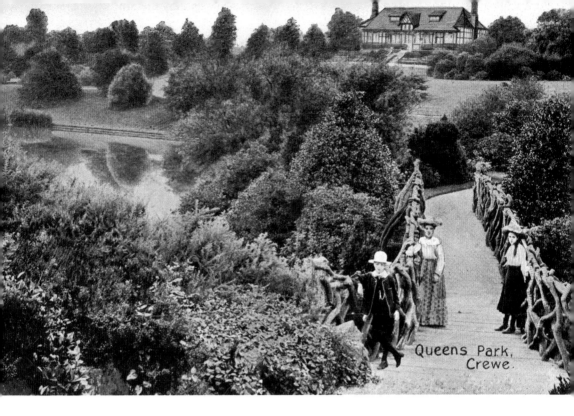

Above: Queens Park, Crewe

Queens Park in Crewe is considered one of the finest parks in Cheshire and the North West. It was opened by the Duke of Cambridge on 9 June 1888, and it is a typical Victorian park. It was built for the people of Crewe by the London & North Eastern Railway (LNER), and it covers an area of 45 acres. There are two lodges inside the gateway, which were built using the sandstone that was removed from the railway cutting leading into Lime Street station in Liverpool. (Historic England Archive)

Opposite above: Drill Hall, Myrtle Street, Crewe

The Crewe drill hall, which provides accommodation for the town's cadet units. It is a former reserve centre, built with others across the country in 1937. (© Historic England Archive)

Opposite below: Drill Hall, Myrtle Street, Crewe

The interior of the drill hall. The building is Grade II listed. (© Historic England Archive)

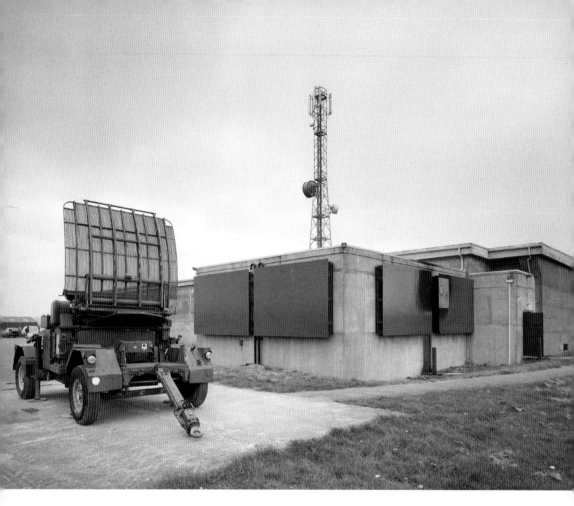

RAF Hack Green

At the start of the Second World War radar was in its infancy and had difficulty in detecting hostile aircraft. In late 1940 a system of radar installations known as 'Ground Controlled Intercept Stations' was developed, and in 1941 Hack Green was chosen, a site previously used as a bombing decoy site for the main railway centre at Crewe. It became RAF Hack Green, and gave early warning of airborne attacks between Birmingham and Liverpool. Thus began the service of Hack Green and its airmen and women in defence of the nation.

Following the Second World War, a major examination of radar capability showed that our existing radar defence would be unable to cope with the threat posed by fast jet aircraft, let alone nuclear missiles. Any operational station needed to be protected against the new threat posed by nuclear weapons. RAF Hack Green had a complement of eighteen officers, twenty-six NCOs and 224 other ranks, so quite a substantial installation is hidden away in pastoral Cheshire. The station was closed in 1966, its role having been transferred to RAF Lindholme in South Yorkshire. The bunker was then abandoned.

In 1976 the abandoned site at Hack Green was purchased from the MOD by the Home Office Emergency Planning Division to be transformed into a protected seat of government. The original radar bunker was converted into a vast underground complex containing its own generating plant, air conditioning and life support, nuclear fallout filter rooms, communications, emergency water supply and all the support services that would be required to enable the 135 personnel to survive a sustained nuclear attack. The Hack Green Nuclear Bunker has since been converted into a visitor attraction. (© Crown copyright. Historic England Archive)

Interior Upper Floor, NAAFI Canteen

The HQ became operational in 1984. It was responsible for a huge area, from Cheshire in the south to Cumbria in the north. A regional commissioner who would have been an appointed civil servant or minister would have headed the HQ. Under the Emergency Powers Act he or she would govern this defence region and neighbouring regions too if other RGHQs had been destroyed. They would attempt to marshal the remaining resources to put the region back on its feet and prepare for the re-establishment of the national government. (Historic Engalnd Archive)

Chester City

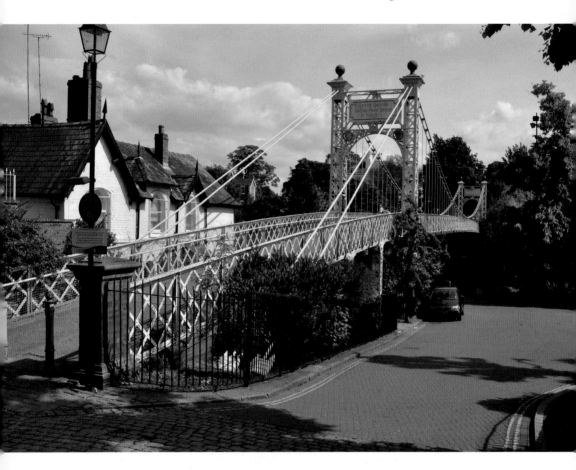

Suspension Footbridge

Setting foot in Chester is like being taken back to the Middle Ages, a place where time seems to have slipped backwards. Can these decorated timber-framed houses like doll's houses actually be for ordinary habitation? The city has a fairy-tale quality with its castle looking down from a high perch, its beautiful cathedral glowing rosily in warm sandstone, the most complete medieval monastic complex still standing in this fair country. There is the ancient stone Old Dee Bridge; the Rows, which convert the pathways into shadowed corridors, once protecting Doulton-like voluminous dresses from the dirt below; and quaint inns with a history drifting back through the centuries. Chester is unique, a city of contrasts and antiquity. We have to thank architects like Penson, Douglas, Lockwood, James Harrison and his namesake Thomas Harrison, who took the already beautiful city and, unlike more modern developments, improved upon it. The photograph here is of the suspension footbridge from the Groves to Queens Park. (Author)

Above left and right: Chester City Walls
A tour around the walls and the city inside them gives a taste of what Chester has to offer.
(Historic England Archive)

Right: Watergate Row, Chester
One of Chester's most famous
historical features is the Rows,
which are continuous, half-timbered
galleries that form a second row of
shops above those at street level. They
can be found along Eastgate Street,
Northgate Street, Watergate Street
and Upper Bridge Street. Nothing
the same exists anywhere else in
the world. The Rows date from the
medieval period and could originally
have been designed to protect the
pedestrian from the ordure and filth
that would have been in the streets at
the time. (Historic England Archive)

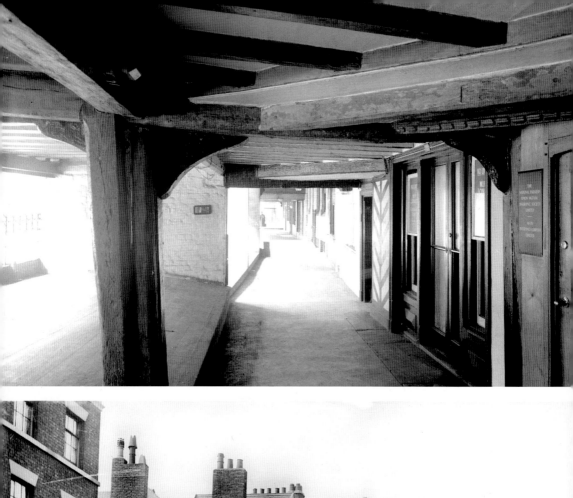
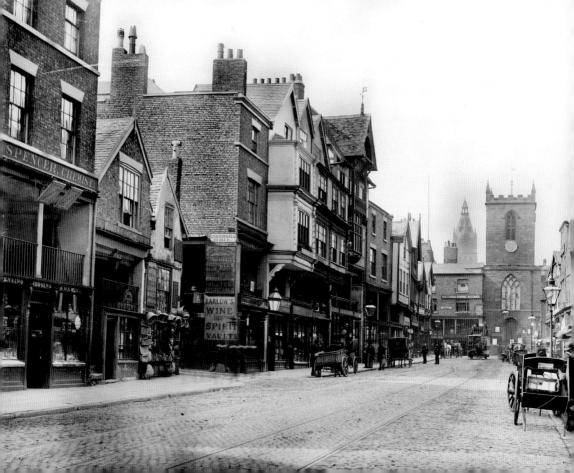

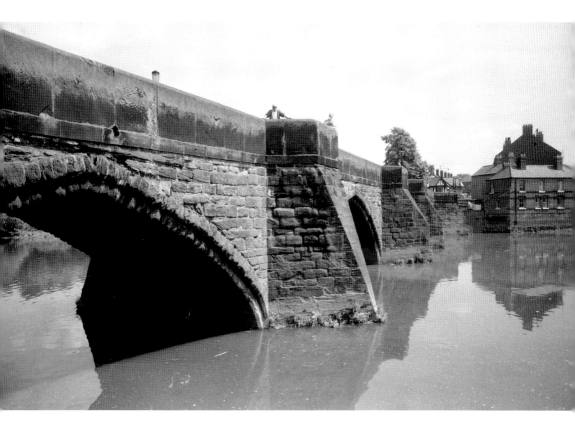

Above: Old Dee Bridge
There is a record of a ferry at this location in 911, but the famous Old Dee Bridge was recorded in the Domesday Book in 1086. The early bridges were made of wood and frequently washed away, so in 1357 Edward the Black Prince ordered the mayor of Chester to build it properly and ordered his own mason and surveyor to assist. The bridge built at this time was the one that we see today, although it has been rebuilt and repaired over the years. It was the bridge that Charles I used to escape the city after his troops were routed – hence, the present bridge dates from around 1357 when the old bridge was rebuilt. In 1825–26 the bridge was widened by Thomas Harrison to provide the footway, and Harrison then went on to design the Grosvenor Bridge a few years later. (Historic England Archive)

Opposite above and below: Upper Bridge Street
A photograph taken of the town in Upper Bridge Street, famous for its Rows (seen in the image opposite above). There were once Rows in Lower Bridge Street too, but due to building work here over the years there are now none left. (Historic England Archive)

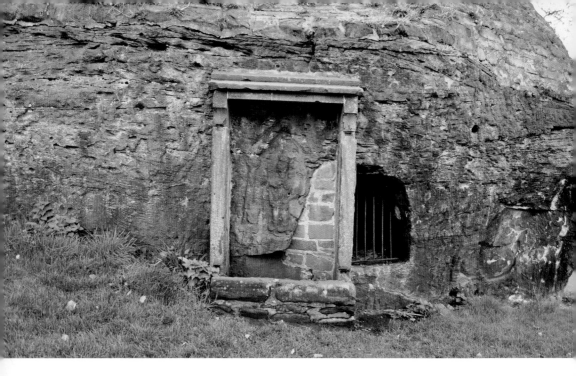

Above: Statue of Minerva, Edgar's Field

Crossing the Old Dee Bridge into Edgar's Field we find a statue of Minerva, the Roman goddess of war. It might not be impressive at first sight, but this is Grade I listed. It is the only monument of its kind in Western Europe that remains in its original position, and a cast of it is in the Grosvenor Museum. The carving has weathered over the centuries and suffered from some vandalism. Next to the shrine is an opening in the rock face that is known as Edgar's Cave. The shrine stands beside the route of the old Roman road that leads into the fortress of Deva from the south. It was the site of a quarry that provided some of the stone for the Chester Walls and other buildings. (Author)

Opposite above: Grosvenor Bridge

Grosvenor Bridge was at one time the longest single-arch bridge in the world, a title that it retained for thirty years. It is designated a Grade I listed building. It is a single-span stone arch road bridge crossing the River Dee and carries Grosvenor Road over the river. It was designed by Thomas Harrison and opened by Princess Victoria of Saxe-Coburg-Saalfeld, soon to become Queen Victoria, on 17 October 1832. (Historic England Archive)

Opposite below: Grosvenor Bridge

At the beginning of the nineteenth century, Chester only had one river crossing: the aforementioned narrow medieval bridge at Handbridge, the Old Dee Bridge. Heavily congested, it delayed movement through the town. Building a new bridge over the Dee was prohibitively expensive until Thomas Telford proposed a new road between Shrewsbury and the Irish ferries at Holyhead to facilitate trade between the two islands. The route would have bypassed Chester, greatly reducing the potential income from the lucrative Irish trade routes. At the time Chester was a major shipbuilding city, so a very tall bridge was required to allow ships to pass underneath. A design by the architect Thomas Harrison featuring a bridge 60 feet (18 metres) high and 200 feet (61 metres) wide was chosen. It was described by chief builder James Trubshaw as 'a lasting monument to the glory and superiority of Great Britain'. Limestone was brought from Anglesey and this together with gritstone made up the building materials. The first stone was laid by the Marquess of Westminster on 1 October 1827, and construction was finally completed in November 1833. (Historic England Archive)

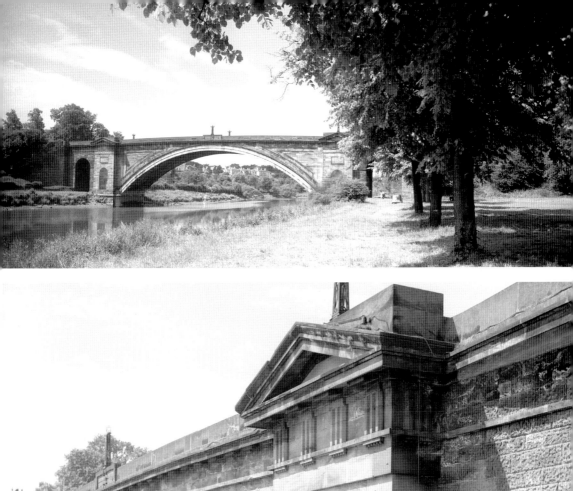

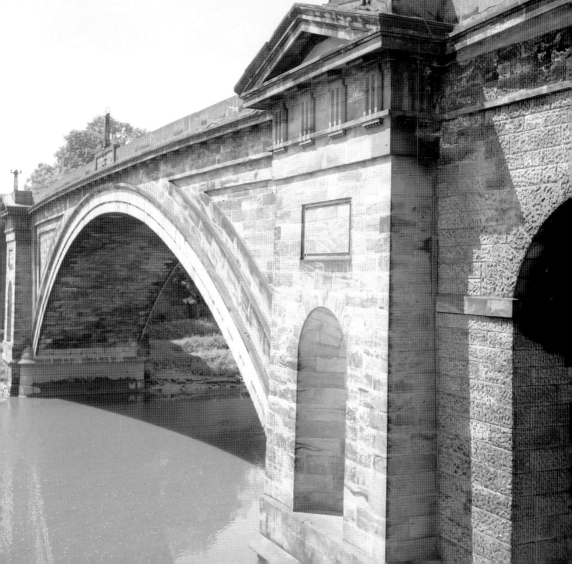

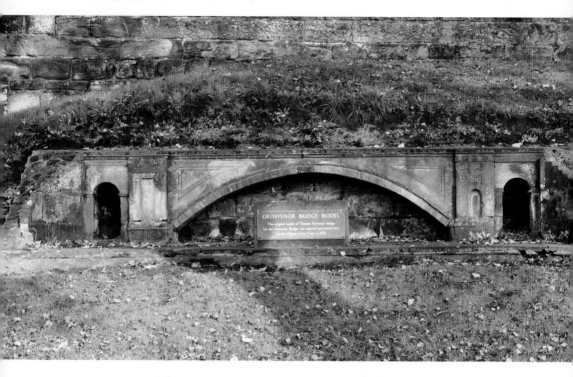

Above: Model of Grosvenor Bridge

Walking up the hill to the main Grosvenor Road we see a scale model of the Grosvenor Bridge set into the banking on the right. This itself is listed and was probably built before the construction of the bridge as a demonstration model. It was originally sited in Raymond Street but moved to this location during the 1980s. (Author)

Opposite above and below: Chester's Racecourse, the Roodee and Cross

On the left of Grosvenor Road (that leads to the bridge) spread out below is the Chester racecourse, known as the Roodee. It is listed as the oldest racecourse in England, and one of the shortest. 'Roodee' is a corruption of 'rood eye', meaning 'the island of the cross'. This comes from a story regarding a statue of the Virgin Mary holding a large cross being buried in the centre of what was then a small island surrounded by water in around the year 946. The river used to run below the walls here during Roman times and trading ships would tie up to unload their cargo directly on to the walls. In the 1500s horse racing was brought to the Roodee. The first recorded race was held on 9 February 1539, but this is disputed by some. The mayor of Chester at the time was Mr Henry Gee, whose name led to the use of the term 'gee-gee' for horses. (Author; Historic England Archive)

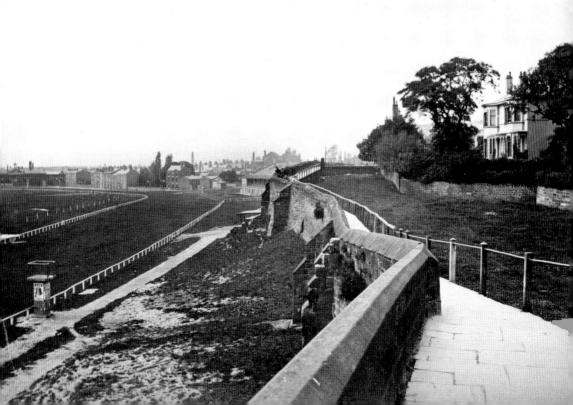

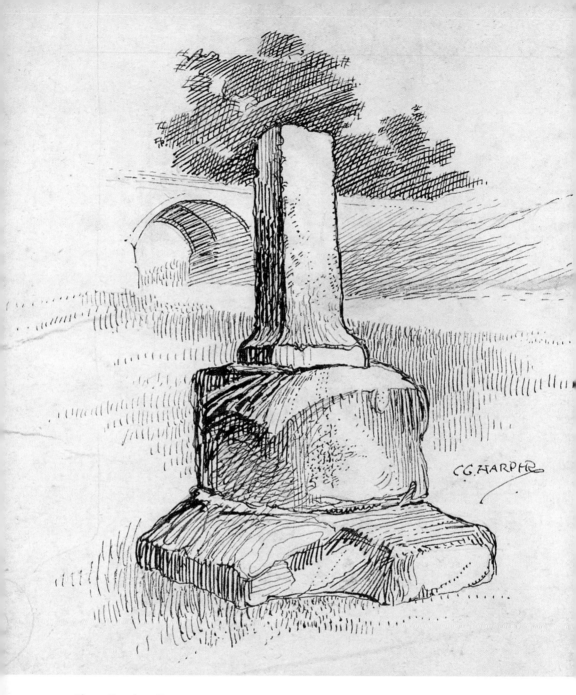

Above: Roodeye Cross
This plinth known as the Roodeye Cross can be seen from the walls. It is a small, insignificant piece of sandstone, but has an important history. It is believed that a statue of the Virgin Mary is buried there and the Roodeye was placed on top. This was when the river reached the city walls, leaving a small island in the middle. It was on this island that the plinth is now sited. (Historic England Archive)

Opposite above: Roodeye Cross
A modern look at the small but important stone pillar that gives the Roodee its name. (Author)

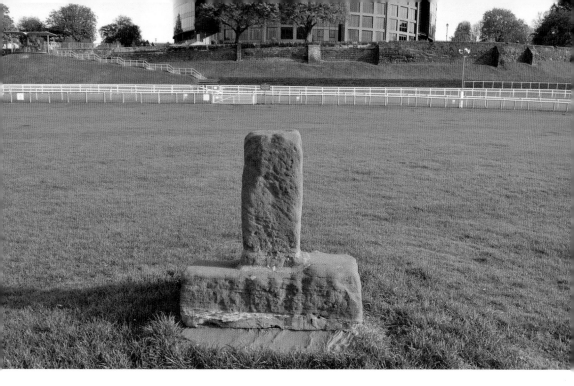

Below: Shire Hall, Chester Castle

Here we have the spectacular gateway and entrance portico to what is now the Crown Courts and Military Museum. The prison was completed in 1792 by Thomas Harrison, who then started work on the medieval Shire Hall in a neoclassical style. He built two wings to the main building: one to act as barracks, now the Military Museum, and one to act as an armoury, later the officers' mess. The main Shire Hall became Chester Crown Court, and Harrison's pièce de résistance was the gateway. He built a massive portico styled in the form of a propylaeum in Greek neoclassical style with four widely spaced Doric columns. Historian Nicolas Pevsner described it as 'one of the most powerful monuments of Greek Revival in the whole of England'. (Historic England Archive)

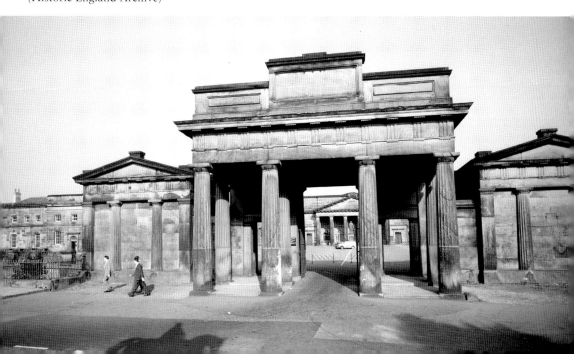

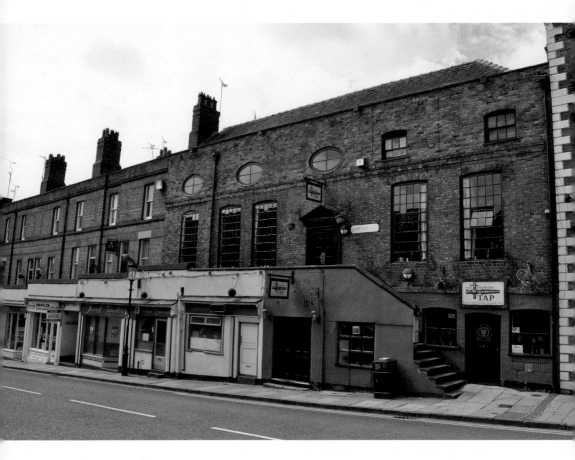

The Brewery Tap

An interesting building in Lower Bridge Street, among many other interesting buildings, is a pub called The Brewery Tap. Set back from the road and up a short stairway, this popular pub stretches far back in Chester's history, playing a very important part in it. Known as Gamul House, the building was once a Jacobean great hall that had been built for the Gamul family, and is the only stone-built medieval hall to survive in Chester. This family were very wealthy merchants in the city and powerful enough to support their own army. This army was lent to Charles I, who stayed here from 23–26 September 1645. Parts of the present Gamul Hall date from around the early sixteenth century, with the oldest visible areas being the wall and fireplace behind the bar. (Author)

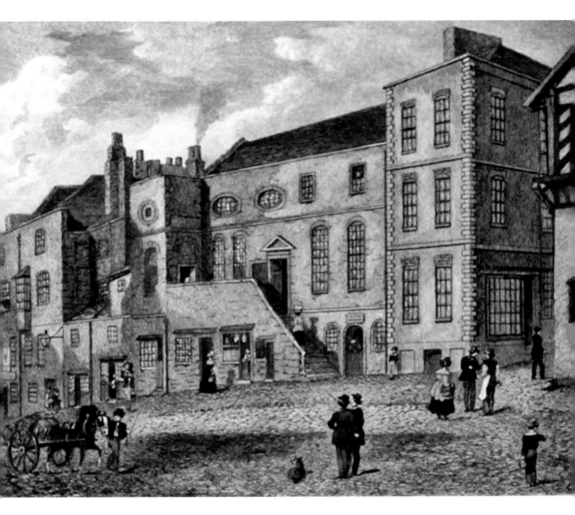

Painting of Gamul House, The Brewery Tap
The Gamul family lived here during the sixteenth and seventeenth centuries. Thomas Gamul was the city's recorder, and his father was mayor on four occasions. His son, Sir Francis, was a staunch Royalist and resided here during the Civil War. He was responsible for the city's defences. The last time that Charles I stayed here was the night before the Battle of Rowton Moor, or Rowton Heath. It was from here that he would have made the short walk to the walls of Chester to watch his army lose decisively to the Parliamentarians. The king made his escape across the Old Dee Bridge and into Wales. The painting is likely to date from the seventeenth century. (Author)

The Falcon Inn

This beautiful old building that sits on the corner of Grosvenor Street and Lower Bridge Street started life as a house in around 1200 and was later extended to the south along Lower Bridge Street, with the Great Hall running parallel to it. It was rebuilt again during the late sixteenth and early seventeenth centuries, and in 1602 it was bought by Sir Richard Grosvenor, who extensively altered it some forty years later to make it his town house. In 1643 Sir Richard petitioned the City Assembly for permission to enlarge his house by enclosing the portion of the Rows that passed through his property. This was successful, and it set a precedent for other residents of Lower Bridge Street to enclose their portion of the Rows too, or to build new structures that did not incorporate them. As a result that street no longer has Rows, unlike the rest of the city centre. In the late eighteenth century the building ceased to be the town house of the Grosvenor family, although it continued to be owned by them, and between 1778 and 1878 it was licensed as The Falcon Inn. In the 1800s it was restored by John Douglas, and The Falcon became the Falcon Cocoa House, serving non-alcoholic drinks only. Through the 1960s the pub lay empty and derelict, but it was later restored by the Falcon Trust and reopened as one of Chester's ancient, popular watering holes. (Historic England Archive)

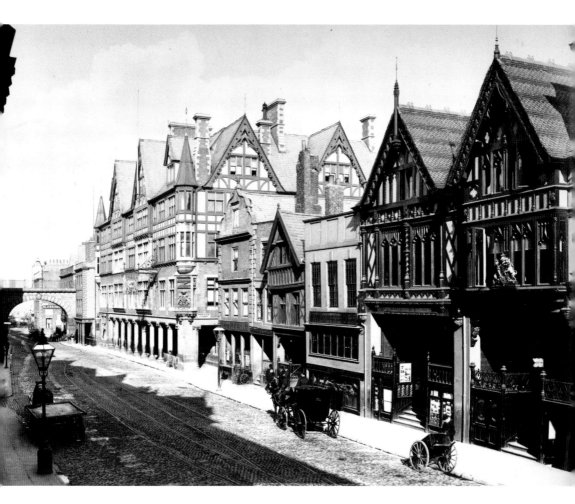

Eastgate Street
Looking along Eastgate Street towards the Eastgate, which has not yet acquired its famous clock. (Historic England Archive)

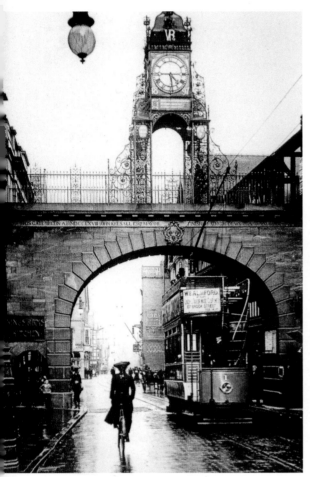 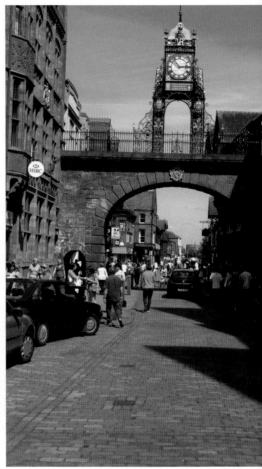

Above left and right: The Eastgate
The Eastgate and its clock, said to be the second most photographed in England after Big Ben. It was designed by the architect John Douglas to celebrate Queen Victoria's Diamond Jubilee and was built by his cousin James Swindley of Handbridge. It was officially unveiled in 1899. (Author)

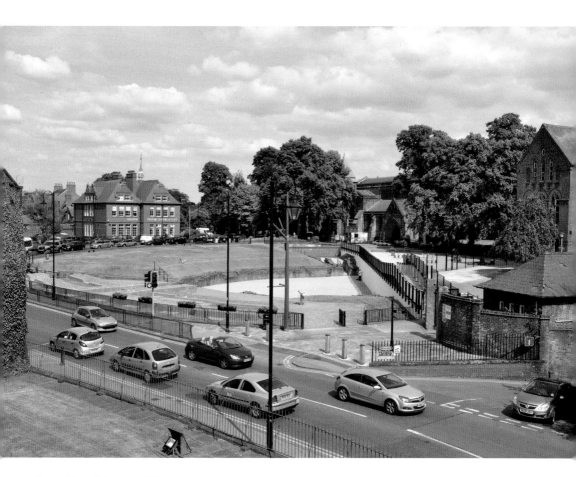

Above: Site of the Amphitheatre

The site of the amphitheatre seems to have long been an open area where citizens came to congregate, play and worship – there was even a bear pit here once. Over the years, however, the site became filled in by natural erosion and was sometimes used as a refuse dump. The arena was still visible as a shallow depression in the ground as late as 1710. Within half a century the northern half of this ancient gem had disappeared under houses and the remains of the monument beneath quickly became lost to memory.

Local historians pondered the location of the amphitheatre, knowing that it was in Chester somewhere but having no idea where it was until a gardener from the Ursuline convent came across some stones during his gardening chores. He had found the Chester Roman Amphitheatre, which had remained completely hidden for so long. The council planned to run a road across it, filling it in again, but fortunately this was not allowed to happen and half of it is now on view, as we can see. (Author)

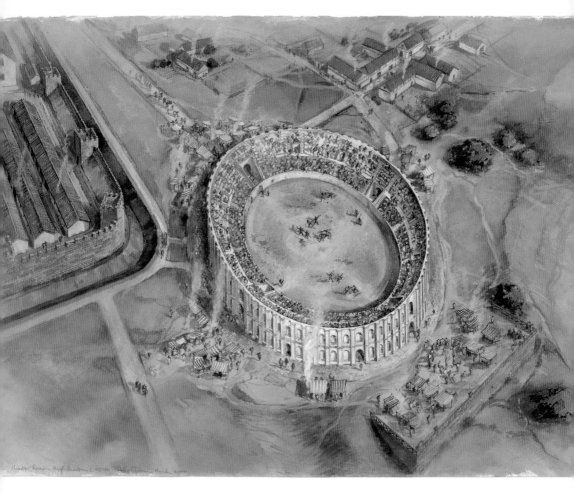

Above: Reconstruction of the Chester Roman Amphitheatre
Here we have an illustration depicting an aerial view of the Chester Roman Amphitheatre as it may have appeared in around AD 100. (© Historic England Archive)

Opposite below: St John's Church
St John the Baptist Church is next to the amphitheatre. In AD 689 King Æthelred of Mercia founded the minster church of West Mercia on what is an early Christian site and known as the minster of St John the Baptist, Chester. This is still there – today St John the Baptist Church – and is an open and active church and a Grade I listed building. The church was, for a while, Chester Cathedral as during the eleventh century Earl Leofric was a benefactor of it. In 1075, Bishop Peter of Lichfield moved his see to Chester, making St John's his cathedral until he died in 1085. His successor moved his seat to Coventry and St John's became a co-cathedral. It was a prominent place of worship, undergoing continuous rebuilding until the Reformation and the Dissolution of the Monasteries, at which time it had much of the east end demolished – the ruins can be seen today. After the dissolution it became a Church of England parish church, which it remains to this day. During the reign of Elizabeth I the nave was restored, and during the English Civil War it was used as a garrison by Parliamentary forces. (Author)

Right: Dee House, Little St John Street

Dee House was built in around 1730 as a town house for John Comberbach, a former mayor of Chester. It continued in use as a private residence until around 1850. In 1925, Dee House was taken over by the Ursulines, a religious order of nuns. Dee House is still there and is sitting on part of the Roman amphitheatre.
(© Crown copyright. Historic England Archive)

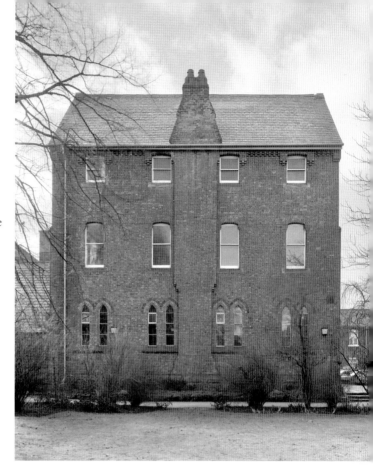

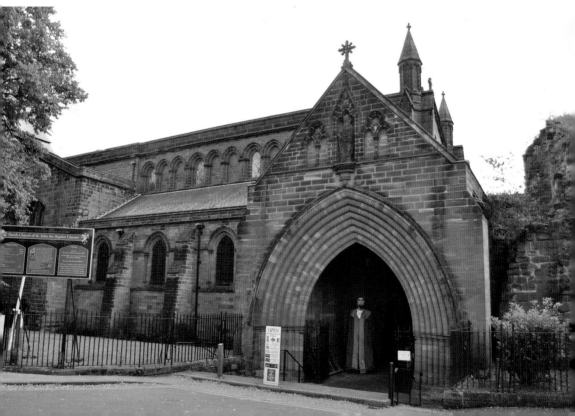

Above: Anchorite Cell by St John's Church
In the church grounds overlooking the River Dee is an anchorite cell or hermitage. This was built to house a monk or nun as a hermit's religious retreat. Grade II listed, it has now been converted into a dwelling house. An anchorite is a person who hides themself away from the world to dedicate their life to God. It is reputed to have been the hiding place of Harold Godwinson, King Harold II, who legend says did not die at the Battle of Hastings as the result of an arrow through the eye, but in fact ended his life in the Chester anchorite cell as a hermit. (© Historic England Archive)

Opposite above: Chester Cathedral
The cathedral was originally a Benedictine abbey dedicated to St Werburgh, established on the site by Hugh Lupus, Earl of Chester, with the assistance of St Anselm and other monks in the late twelfth century – early parts of the structure date from this period. At this time Chester Cathedral was not located at this site, but was at the nearby St John the Baptist Church in what is now St John Street. In 1538, during the Dissolution of the Monasteries, the Benedictine monastery was disbanded and the shrine to St Werburgh was desecrated. In 1541 the building became a cathedral of the Church of England by order of Henry VIII, and the name was changed to Christ and the Blessed Virgin. (Historic England Archive)

Opposite below: Interior of Chester Cathedral
The late fourteenth-century choir stalls and the choir screen constructed by Sir George Gilbert Scott in 1876 can be seen here. (Historic England Archive)

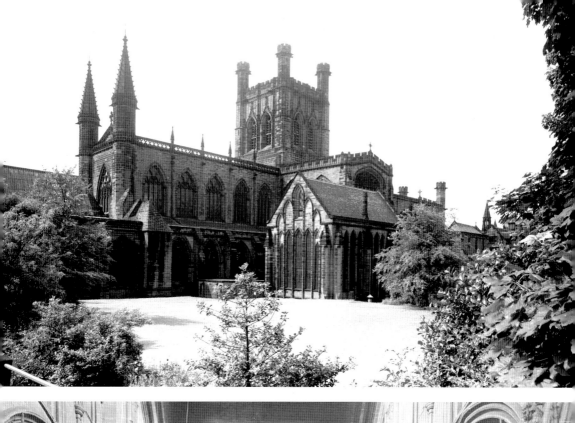

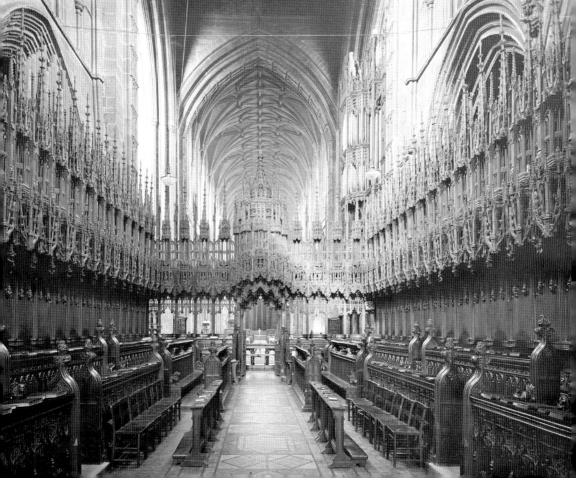

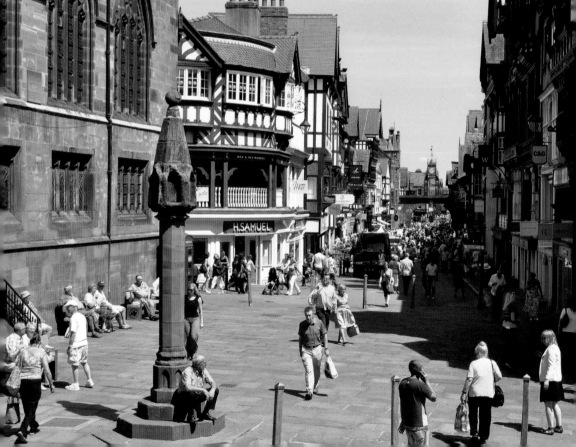

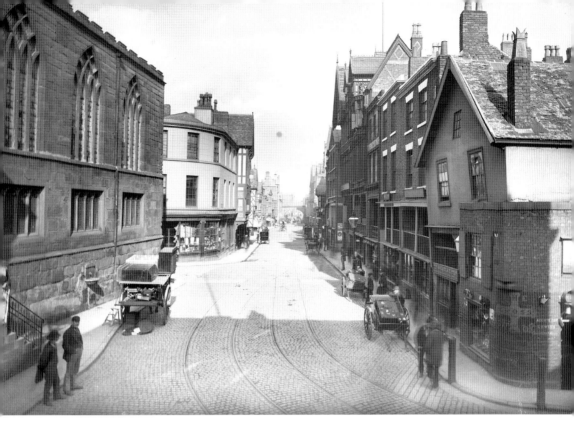

Above: Eastgate Street
Looking from the upper storey of a building on the corner of Bridge Street and Watergate Street around 1870. This area has always been of great importance to Chester. It was here that Charles I was declared a traitor in 1649. (Historic England Archive)

Opposite above: Abbey Chambers, Chester
Abbey Square formed part of the precinct of the cathedral. It is surrounded by eighteenth-century houses and the column on the green is from the former Chester Exchange. The cathedral can be seen in the background. (Historic England Archive)

Opposite below: The Chester Cross
At the end of Upper Watergate Street we find Chester's most famous antiquity, the Chester Cross. The cross is at the junction of Northgate, Eastgate, Watergate and Bridge streets. The centre of the city for hundreds of years, it was also the location of the Roman Principia, which would have been where the Church of St Peter now is. The roads were set out in this fashion by the Romans, each road leading away from the cross in the city centre. This medieval cross was destroyed, like others, during the Civil War in the name of iconoclasm when religious artefacts were summarily smashed and carried off. In the case of the Chester Cross, these artefacts were used elsewhere; for instance, under the steps in the church, and the base was taken to Plas Newydd, the home of the Ladies of Llangollen, where it still lies. The only truly original piece is the top of the shaft, which once contained small statues in the niches. It was not until 1804 that some pieces of the cross were recovered from beneath the church steps and given to Sir John Cotgreave for use in the garden of his new house – Netherleigh – at Handbridge, but eventually they were returned to the city. The head of the cross went to the Grosvenor Museum. Eventually, the cross, with new additions, was re-erected elsewhere and, later still, returned in the 1970s from whence it came. (Author)

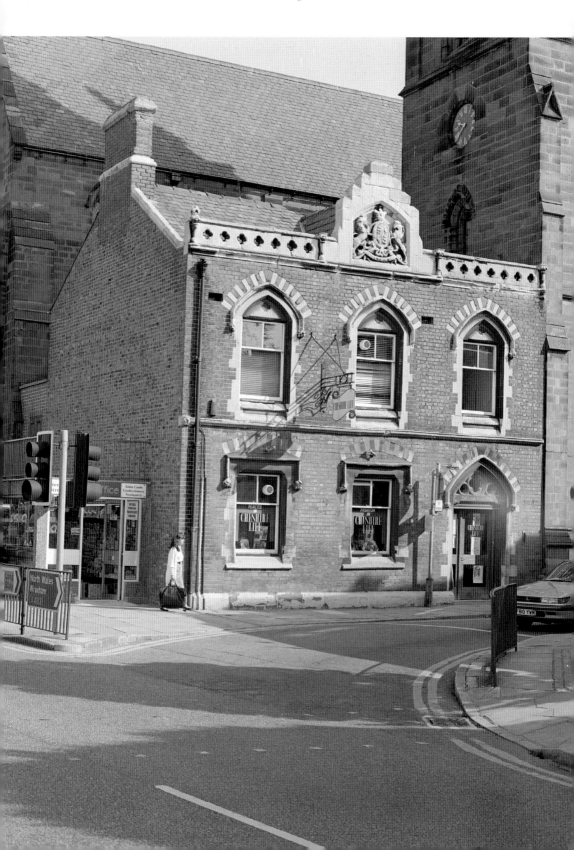

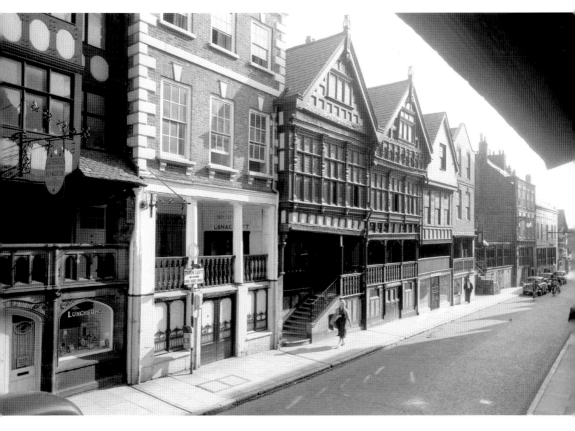

Above: Watergate Street

Watergate Street ran from the Watergate to the Chester Cross on the junction of Upper Watergate Street. On the corner is the building that used to be Holy Trinity Church. The original church that occupied this site probably dated from the fourteenth century, perhaps serving the seamen from the port below. The present church was built between 1865 and 1866 to a design by James Harrison, but he died before the building was completed. The church closed in 1960 and since then has been Chester's Guildhall. (Historic England Archive)

Opposite: Old Customs House, No. 70 Watergate Street

In the days when Chester was a thriving and important port, goods were brought ashore from ships arriving from all corners of the world. They would be brought up Watergate Street from the Watergate to the Customs House, where dues would be paid before onward transmission for sale in the city centre and elsewhere. From the Middle Ages to Tudor times the comptroller of Chester Port was responsible and senior to the ports from Barmouth in Mid Wales as far as the Scottish Borders, including the port of Liverpool. The offices for most of this time were situated within the Chester Castle precincts until 1633.

The old Customs House is situated at No. 70 Watergate Street. It was thought to have been built in 1633 when the customs offices were transferred from Chester Castle. The building was rebuilt in 1868 to a design by James Harrison before his death at the age of fifty-two in 1866. By the beginning of the 1800s, Chester's importance as a port had vastly diminished, although the Customs House continued to support a staff of seven almost to the end of the century. (Historic England Archive)

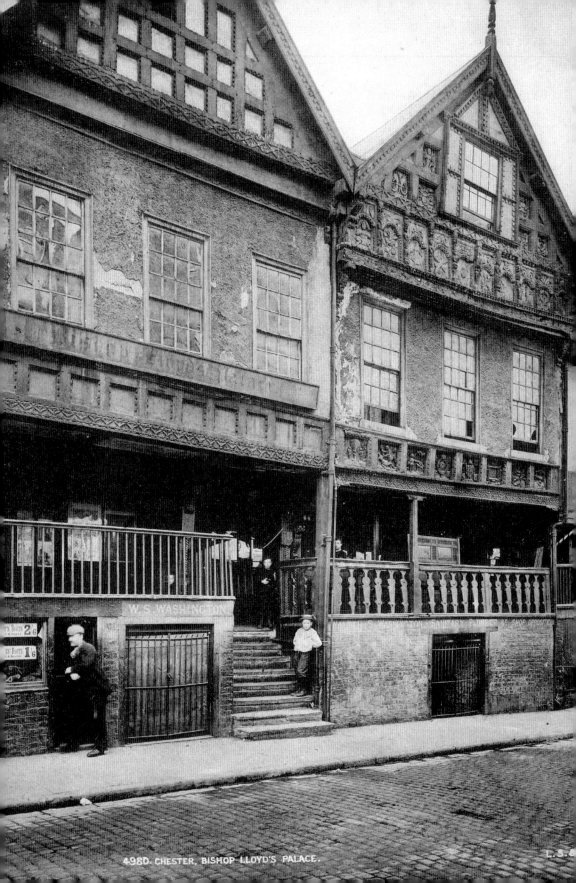

498D. CHESTER, BISHOP LLOYD'S PALACE.

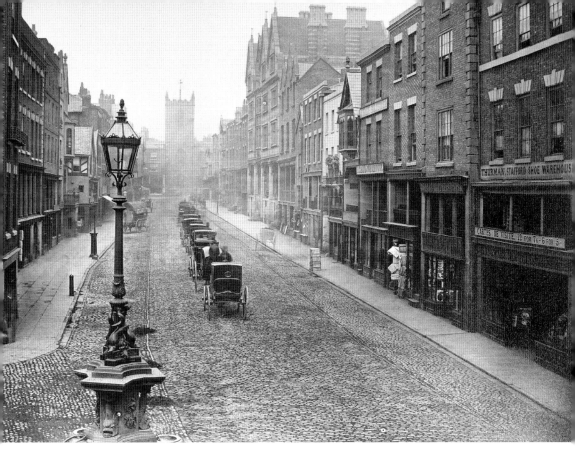

Above: Bridge Street

A very old photo, dated 1860, looking towards the tower of St Peter's Church and showing a row of horse-drawn cabs. In the distance are the site of the Chester High Cross and the church. The parish dedicated to St Peter was founded in AD 907 by Lady Æthelfleda, and some of its fabric dates from that time. The church stands on the site of part of the Roman Praetorium and was, in 1086, referred to as 'Templum Sancti Petri' in the Domesday Book. The present church dates from the fourteenth, fifteenth and sixteenth centuries, with further modifications in the following three centuries. The tower once had a spire, which was removed and rebuilt in the sixteenth century, taken down in the seventeenth century, then rebuilt and finally removed 'having been much injured by lightning' in around 1780. In 1849–50 the church was repaired by James Harrison, and in 1886 it was restored by John Douglas, which included the addition of a pyramidal spire. (Historic England Archive)

Opposite: Bishop Lloyd's House

Situated at Nos 41–42 Watergate Street is a building known as Bishop Lloyd's Palace. This ancient house originated as two town houses that were built on medieval undercrofts and then rebuilt during the seventeenth century when the two buildings were converted into one. The house has been associated with George Lloyd, who was firstly Bishop of Sodor and Man (1599–1605) and the Bishop of Chester (1605–15) until he died. This probably accounts for the seventeenth-century carving on the front elevation that includes the Legs of Man and three horses' heads for both the bishopric and the Lloyd family. By the nineteenth century it had become rundown: the carvings on its frontage had been covered with plaster and the house was becoming derelict. In the 1890s the house was heavily restored by Thomas Lockwood, and further restoration was carried out between 1973 and 1977. The building now houses the Chester Civic Trust and is available for visits and hire subject to the trust. (Historic England Archive)

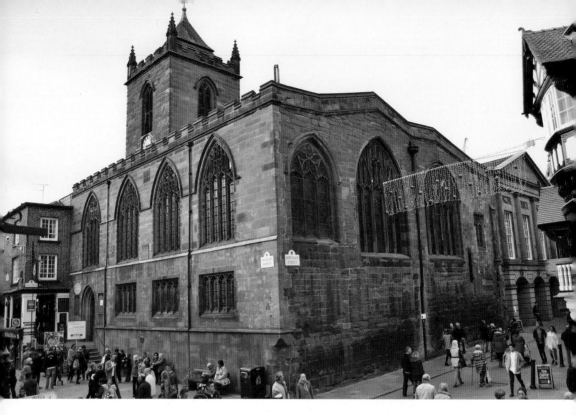

Above: Church of St Peter

The Church of St Peter now looks down serenely into Bridge Street and is a Grade I listed building. Note the church clock. There has been a clock on the tower since 1579 when one was purchased for the sum of 2*s* 6*d*. It had to be regularly wound. In 1736 it was illuminated by gas and in 1855 the council took over the job of illuminating it. It was only in 1973 that the need to wind it by hand ceased and electricity took over. (Author)

Below: Lower Bridge Street

A 1915 view looking south along Lower Bridge Street, showing the buildings at the junction with Shipgate Street, with the Bridgegate beyond. (Historic England Archive)

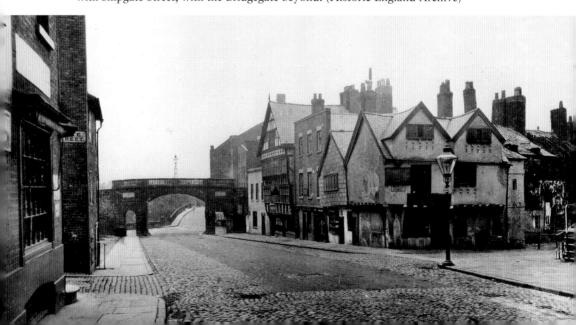

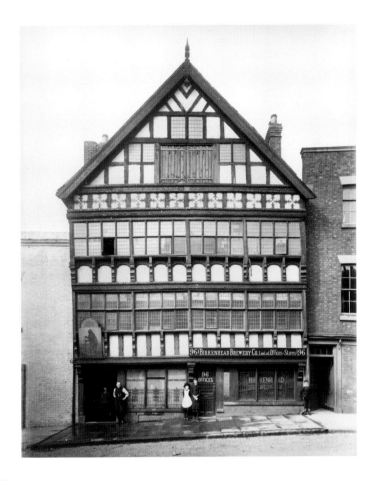

Bear & Billet

Situated at the bottom of Bridge Street is the Bear & Billet, seen in this photo of 1880. The Bear & Billet is one of Chester's best-known pubs. It has had a chequered history lately, but still retains the ambience of old. It was built in 1664, a date that is prominently shown on the front elevation. Before this there was an ancient building that was destroyed during the English Civil War. It is one of the last wooden buildings built in the city, constructed as the town house for the Earl of Shrewsbury, who was at the time one of the serjeants of the Bridgegate. This entitled him to collect tolls from people passing through the nearby gate. In 1820 General Grosvenor was thrown from the Dee Bridge into the river by his political opponents as he was crossing in his carriage, and he was given help and safety at the pub. It has been a pub since the eighteenth century and was at one time known as the Bridgegate Tavern. Due to its proximity to the Dee Mills there is evidence to show that it may also have been a grain warehouse: in the gable end there is a hoist above a set of double doors.

It is recorded as a Grade I listed building and has been described as 'the finest seventeenth century timber-framed town house in Chester and one of the last of the great timber-framed town houses in England'. Its name could be taken from the heraldic device on the arms – not of the Earl of Shrewsbury but of the Earl of Warwick – that consists of a bear tied to a billet or stake. However, according to the *Dictionary of Pub Names*, the Bear & Billet is not referring to any heraldic symbol, but billet is being used in its older sense – a thick piece of wood used as a weapon. John Lennon's maternal grandmother, Annie Jane Milward, was born at the pub in 1873 and lived there until she was in her twenties. (Historic England Archive)

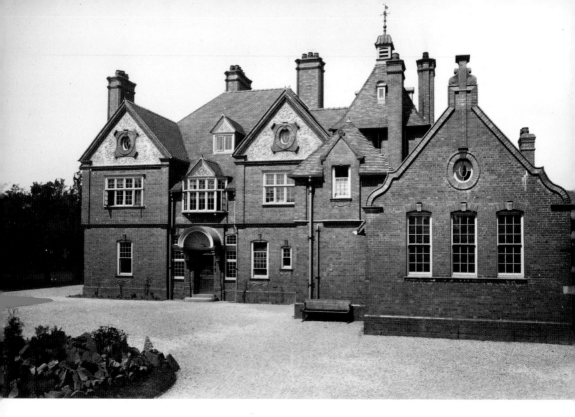

Above: St Mary's Rectory, Overleigh Road, Handbridge
The rectory served St Mary Without-the-Walls Church, which was built in 1887 to replace the original St Mary's-on-the-Hill, which has now become the Chester Heritage Centre. St Mary's Handbridge Centre is a modern and popular venue. St Mary-on-the-Hill is situated at the rear of the Crown Court and Military Museum. (Historic England Archive)

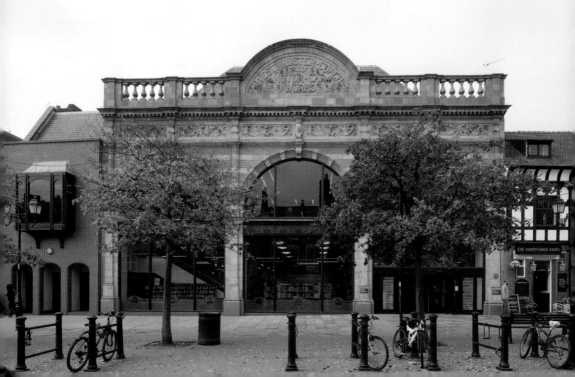

Right and opposite below:
Former Coach and Car Works
The original bus station was
situated beside the attractive
Westminster Coach and Motor
Car Works building, which
has an elaborately moulded
terracotta and red-brick façade.
This most attractive building
was built in 1913 to a design
by Philip Lockwood to house
a coach-building workshop
and motor showroom.
Cars were sold from the
showrooms up until the 1970s.
(© Historic England Archive)

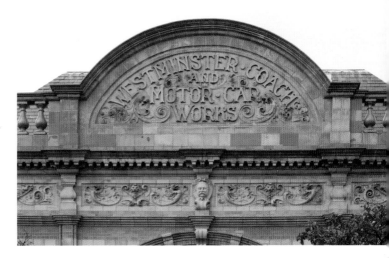

Seven Steps, Parkgate
Parkgate, with its promenade,
but now no water, stands on
the River Dee Estuary. It was
once an important port in its
own right, especially when the
Dee silted towards the port at
Chester. Parkgate was the home
of the packet boats to Ireland.
Handel awaited his ship here
and Nelson's mistress Emma
Hamilton came from nearby
Ness and would bathe here.
A popular holiday destination
with golden sands and ships
moorings, it is now a salt marsh
wasteland all the way to Wales
across the estuary.
 This Grade II listed house
on the promenade is one of
Parkgate's earliest houses.
It dates from 1729 and was
thought to be part of the row
that provided accommodation
for people awaiting their ships.
(© Historic England Archive)

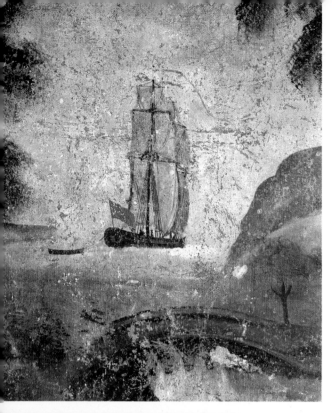

Left: Interior of the Seven Steps House The steps to the front door of the row were raised sufficiently to avoid the ingress of seawater in rough weather. Paintings were found under many years of wallpaper, which we see on the first-floor front bedroom wall. (© Historic England Archive)

Below: Interior of the Seven Steps House Here we see another exposed painting on the first-floor front bedroom wall. (© Historic England Archive)

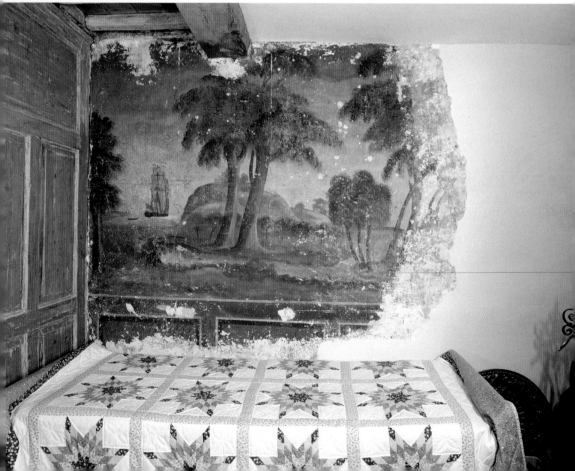

Warrington Area

Before 1974 Warrington was part of Lancashire, but became part of Cheshire under the changes actioned under the Local Government Act of 1972.

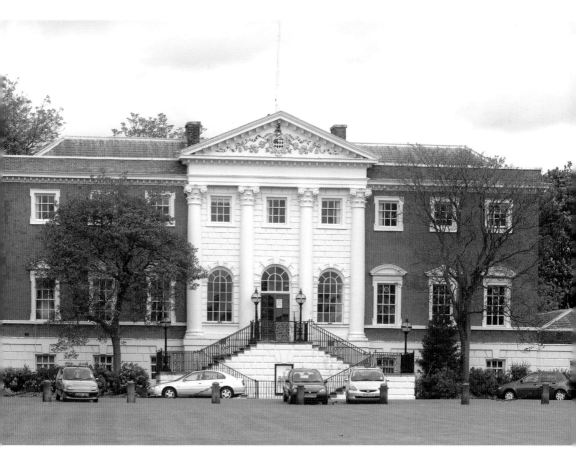

Warrington Town Hall, Sankey Street
Warrington Town Hall was designed by the architect James Gibbs and built in 1750 for wealthy local businessman Thomas Patten. It was originally known as Bank Hall. (© Historic England Archive)

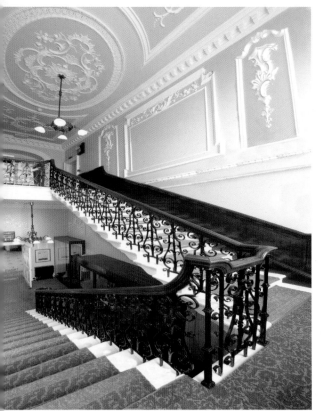

Left: Warrington Town Hall
Here is a view of the staircase in the Town Hall. By 1873 the house was in the possession of Colonel Wilson Patten, later to become Lord Winmarleigh. In this year he sold the building to the council and it became Warrington Town Hall. It is now Grade I listed. (© Historic England Archive)

Below: Town Hall Gates
These gates were made at the Coalbrookdale Company at Ironbridge in Staffordshire. They were made from cast iron as a gift for Queen Victoria and displayed at the International Exhibition in London in 1862. The queen, however, declined the gift, and they were returned to Ironbridge. In 1893, Frederick Monks, a member of the council, saw them and decided to make a gift of them to Warrington Borough Council. The four statues atop each pillar are of Nike, goddess of victory. Originally the grounds were surrounded by iron railings, but these were removed for the war effort in the 1940s. Above the gates are the arms of Warrington Borough Council. (© Historic England Archive)

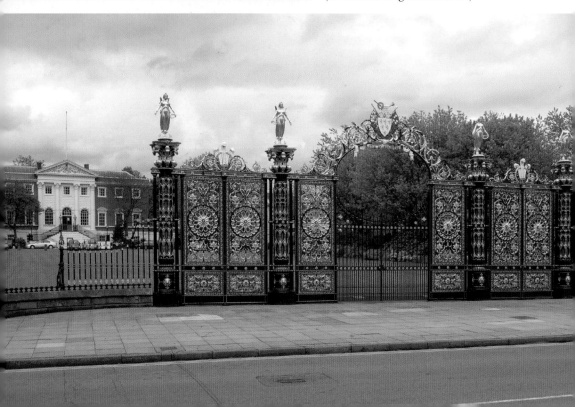

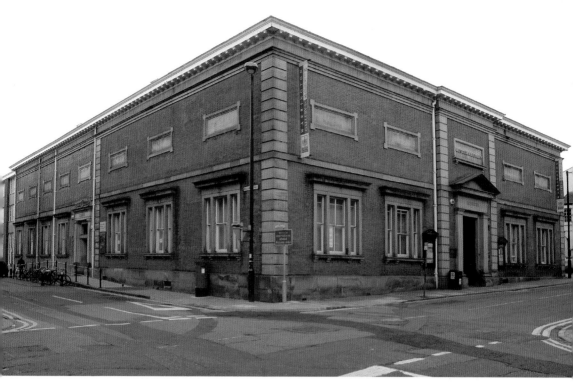

Above: Warrington Museum and Art Gallery, Bold Street

The Warrington Museum and Art Gallery is situated in Bold Street, which is classed as the Cultural Quarter of the town. The building itself is Grade II listed and it also includes the town's library. It has another claim to fame in that it was originally opened at a different location in 1848 and was the first rate supported library in the UK. The current museum and library have been at this location since 1858. (© Historic England Archive)

Right: Warrington Museum and Art Gallery

This photo is from the second floor of the Museum and Art Gallery. (© Historic England Archive)

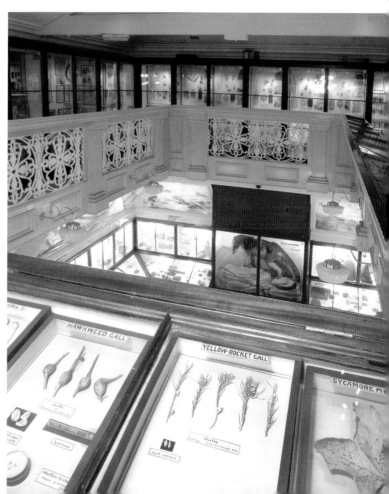

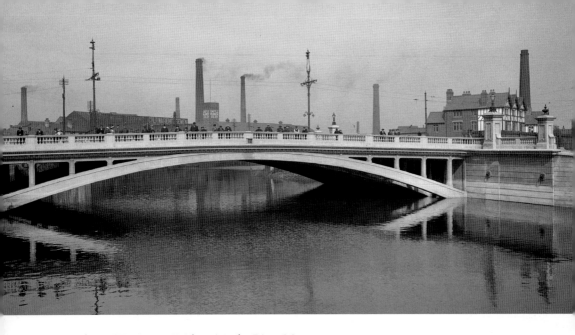

Above: Warrington Bridge over the River Mersey
Seen here from the west with warehouses and factories visible in the background is the bridge over the River Mersey in 1915. There are now two bridges in the area, which is known as Bridgefoot. (Historic England Archive)

Below: Greenall Whitley's Brewery, Wilderspool Causeway
Warrington was once the main brewing centre of Cheshire, home to Burtonwood Brewery, Greenall Whitley and Tetley's. The brewery itself has now closed, as has Tetley's, and the Burtonwood Brewery is part-owned by Molson Coors. (© Crown copyright. Historic England Archive)

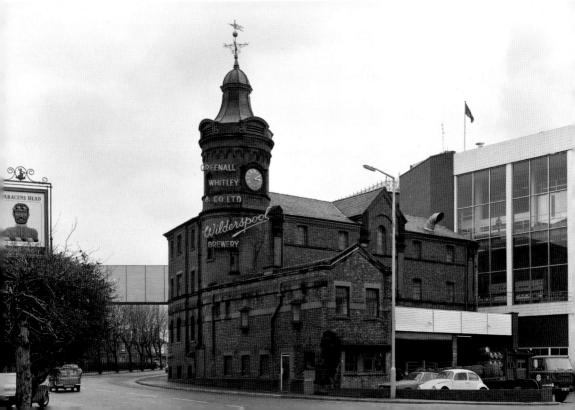

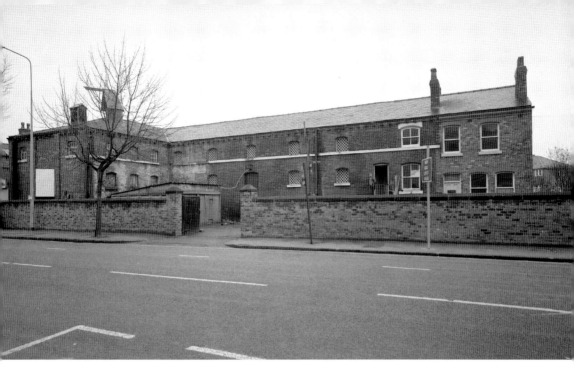

Above: The Maltings, Wilderspool Causeway
This image shows the Maltings, part of the Greenall Brewery on Wilderspool Causeway.
(© Crown copyright. Historic England Archive)

Below: The Maltings, Wilderspool Causeway
Another look at the Maltings building, which has now been put to other uses. (© Crown copyright. Historic England Archive)

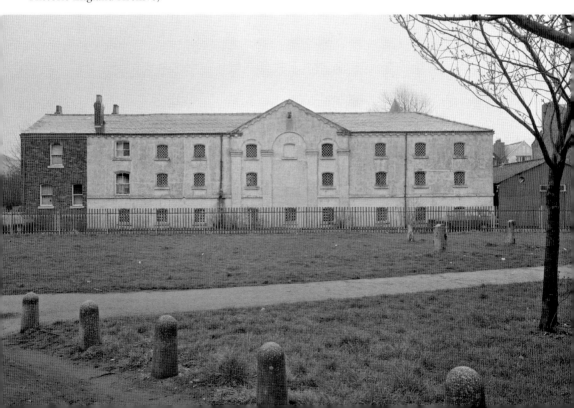

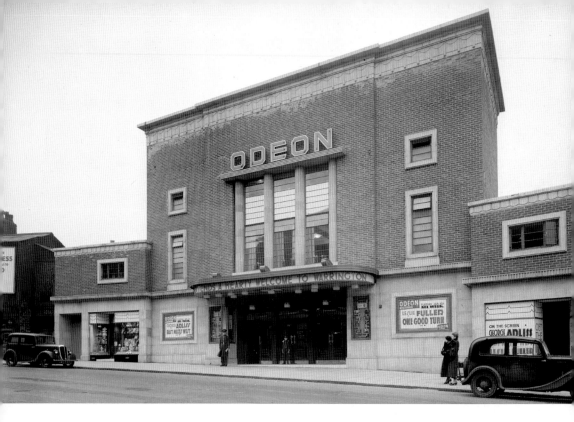

Above: Odeon, Buttermarket Street
The Odeon cinema in Buttermarket Street was built in 1937 and opened on 11 January, making this the earliest photograph taken of it. The cinema was closed in early 1968 after a fire and reopened in May the same year. During the repairs the seating was increased. (Historic England Archive)

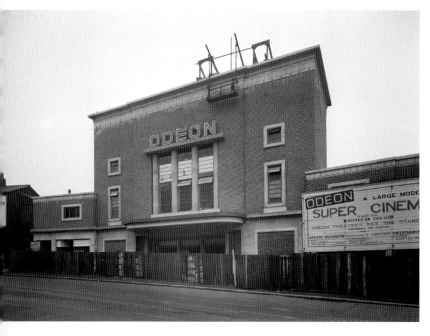

Odeon, Buttermarket Street
After more work to provide an additional screen, the cinema reopened on 14 September 1980. (Historic England Archive)

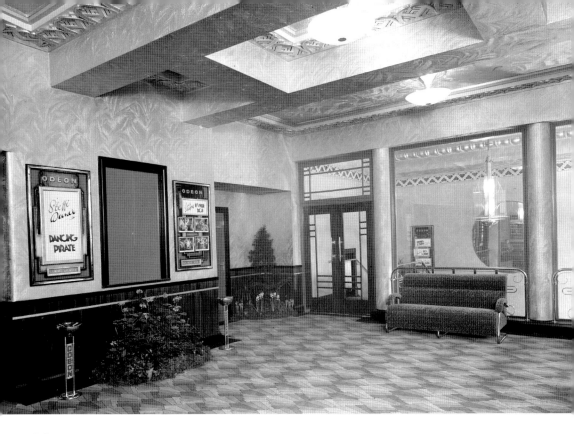

Odeon Foyer
The foyer – again taken when the cinema was new. It was closed on 28 August 1994 and demolished. A Yates Wine Lodge was erected on the site. (Historic England Archive)

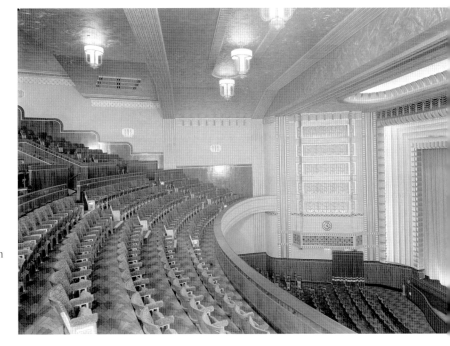

Odeon Auditorium
A photo of the interior, showing the auditorium. (Historic England Archive)

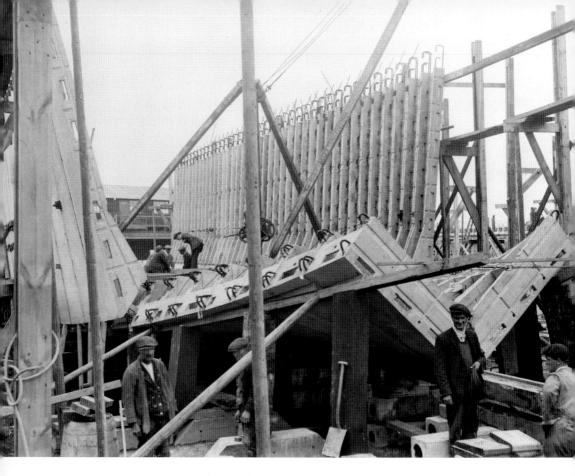

Above: Concrete Seacraft Company, Fiddlers Ferry, Penketh
During the First World War a programme of concrete shipbuilding was undertaken by the Concrete Seacraft Company. The company was set up on 26 January 1918 at Fiddlers Ferry. Here (above and opposite above) we see two 1918 photographs of the ship *Cretecamp* under construction. (Historic England Archive)

Opposite above: Concrete Seacraft Company, Penketh
Cretecamp was launched in 1918 for the Board of Trade and then sold to Norway in 1922. In that year the company name was changed to Williams, Tar and Company. The company then went from strength to strength, erecting concrete bridges and all forms of buildings for industry. What started off as a company building concrete boats became a major player in all forms of concrete and other construction. Williams, Tar and Company celebrated 100 years on 26 January 2018. (Historic England Archive)

Opposite below: Walton Cutting, Manchester Ship Canal
The Manchester Ship Canal from Liverpool to Manchester passes through the centre of Warrington. Here we see the building of the canal in 1887. It shows the piers for the swing bridge and the entrance to Warrington Docks. (Historic England Archive)

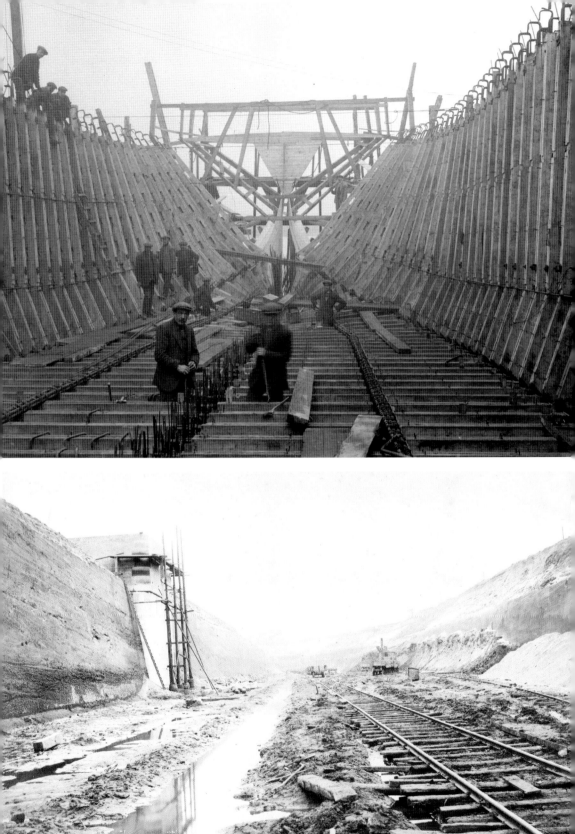

Latchford Viaduct, Grappenhall and Thelwall
Work is in progress at Latchford with the viaduct in the background and the high bridge that is still there allowing ocean-going ships to navigate the canal. (Historic England Archive)

Acton Grange, Manchester Ship Canal
A view of the building of the canal in the Acton Grange area of Warrington. (Historic England Archive)

Above: HMYOI Thorn Cross, Anley Road, Appleton
HMS Blackcap, Royal Naval Air Station Stretton, was commissioned on 1 June 1942. It was also an aircraft maintenance yard. After the war, it was engaged in scrapping US aircraft that were flown there for the purpose. It became the base of other navy squadrons until November 1959 when it closed and the navy moved out. In 1960 it was acquired by the prison commissioners and was turned into an open prison for adult males. (© Crown copyright. Historic England Archive)

Below: HMYOI Thorn Cross, Anley Road, Appleton
In 1981 the prison closed, and from 1982 to 1985 it was converted into HM Young Offenders Institution (HMYOI) Thorn Cross. It was created as one of two HIT units (High-Intensity Training Units), better known as 'boot camps'. The second one was at the Military Corrective Training Centre, Colchester. (© Crown copyright. Historic England Archive)

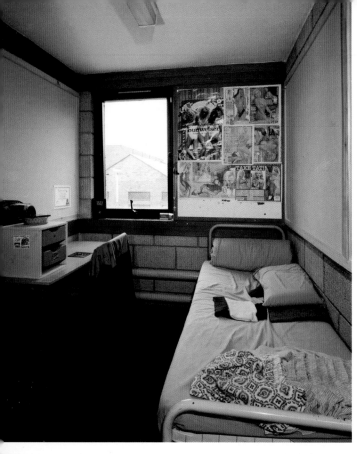

Left: HMYOI Thorn Cross, Anley Road, Appleton
Thorn Cross is now a Category D institution for men over twenty-one. This is an example of one of the cells. (© Crown copyright. Historic England Archive)

Below: HMP Risley, Warrington Road, Risley, Croft
Warrington has a second important prison. HMP Risley is known by the inmates as 'Grisly Risley'. Seen here is the activities and hospital building within the prison. (© Crown copyright. Historic England Archive)

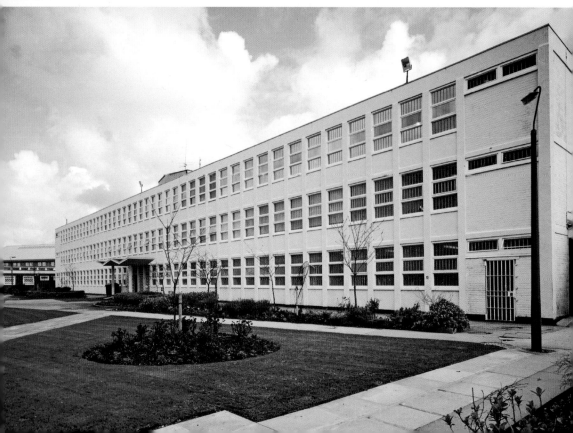

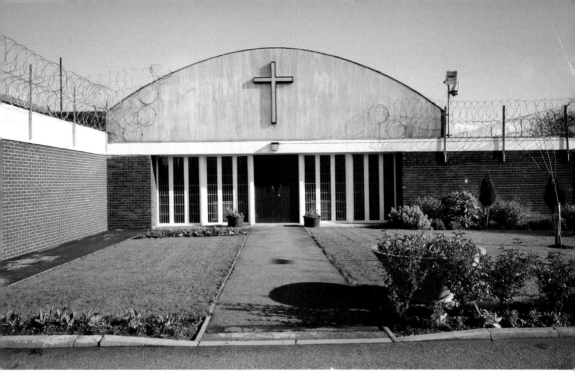

Chapel, HMP Risley
Risley opened as a purpose-built remand centre for both male and female inmates in 1964. It remained in that capacity until 1990 when a Category C prison opened alongside the remand centre. In April 1999 Risley ceased to hold female prisoners, and in March 2000 it became a Category C prison solely for adult males. (© Crown copyright. Historic England Archive)

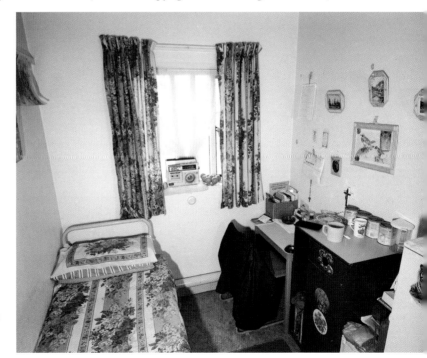

HMP Risley
One of the cells in
HMP Risley. (© Crown
copyright. Historic
England Archive)

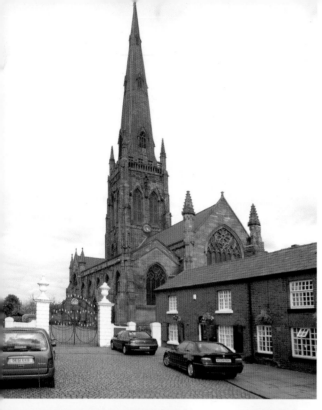

St Elphin's Church, Church Street, Warrington
A church has been on this site since around AD 650. This Grade II listed building was built by Sir William Boteler in 1354, but was badly damaged during the English Civil War. In the years that followed much of the church was rebuilt. (© Historic England Archive)

Eastbound Burtonwood Service Station
This unique service station architecture is located on the M62 at Burtonwood from the south. The M62 was built across the wartime Burtonwood RAF and US base. The services were opened in 1974. The conical-shaped roofs were designed by the architect Francis Gwynne. They served the motorway well with services on each side, but in 2008 the westbound side was closed and demolished. Traffic coming off at this side had to cross over to the eastbound side via the roundabout and bridge.
The westbound site is being redeveloped as Gemini 8, being adjacent to the Gemini Retail Park. (© Historic England Archive)

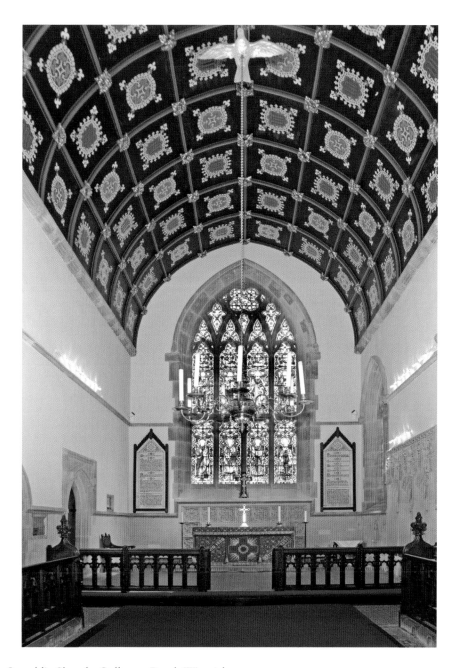

St Oswald's Church, Golborne Road, Winwick
An interior view of this beautiful Grade I listed church, parts of which date from the thirteenth century. Like the last church featured, much damage was caused to this building by Parliamentary troops when Oliver Cromwell housed them in the church during the Civil War – in this case after the Battle of Red Bank. On Thursday 13 January 1887 the man who was to captain the SS *Titanic* on its fateful maiden voyage, Captain Edward Smith, married Sarah Eleanor Pennington here. (© Historic England Archive)

Runcorn and Widnes

Like Warrington, Widnes was part of Lancashire until 1974.

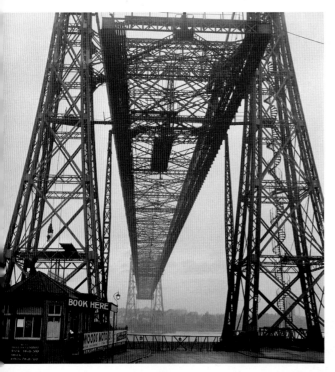

Left and below: Transporter Bridge
This transporter bridge conveyed passengers and vehicles across the River Mersey between Runcorn and Widnes from 1905 until 1961. The transporter was opened in 1905 and was the largest bridge of this type. It was demolished after 1961. (© Historic England Archive; Historic England Archive)

Opposite above: Transporter Bridge
The bridge was built in 1961 to ease the flow of traffic over the river. This bridge is now closed undergoing refurbishment, and a quite spectacular bridge has been built and opened nearby. (© Crown copyright. Historic England Archive)

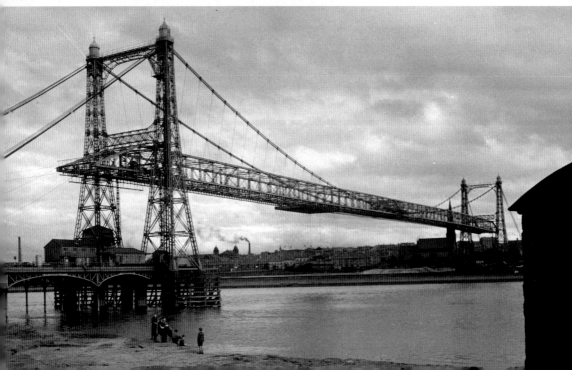

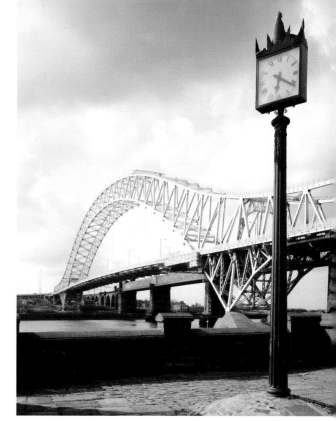

Below: Hooton Hall, Ellesmere Port
Hooton Hall was one of the most prestigious houses in the North West, if not in the whole of Britain. It was built in 1788 to replace the previous house on the site, which had been demolished by Sir William Stanley. After seventy years the house was sold, due to gambling debts, to a banker from Liverpool. When the Manchester Ship Canal cut through the grounds, he relocated to his other seat in Nottinghamshire and abandoned Hooton Hall. During the First World War it was a hospital and army barracks, and the grounds turned into an airfield. After the war, the military retained the airfield until 1957. The house itself had suffered, and in 1932 it was demolished. In 1962 work to build the huge Vauxhall car plant began and it now covers the land that once housed Hooton Hall. (Historic England Archive)

About the Archive

Many of the images in this volume come from the Historic England Archive, which holds over 12 million photographs, drawings, plans and documents covering England's archaeology, architecture, social and local history.

The photographic collections include prints from the earliest days of photography to today's high-resolution digital images. Subjects range from Neolithic flint mines and medieval churches to art deco cinemas and 1980s shopping centres. The collection is a vivid record both of buildings that are still part of everyday life – places of work, leisure and worship – and those lost long ago, surviving only in fragile prints or glass-plate negatives.

Six million aerial photographs offer a unique and fascinating view of the transformation of England's towns, cities, coast and countryside from 1919 onwards. Highlights include the pioneering photography of Aerofilms, and the comprehensive survey of England captured by the RAF after the Second World War.

Plans, drawings and reports provide further context and reconstruction artworks bring archaeological sites and historic buildings to life.

The collections are housed in a purpose-built environmentally controlled store in Swindon, which provides the best conditions to preserve archive items for future generations to enjoy. You can search our catalogue online, see and buy copies of our images, as well as visiting our public search room by appointment.

Find out more about us at HistoricEngland.org.uk/Photos
email: archive@historicengland.org.uk
tel.: 01793 414600

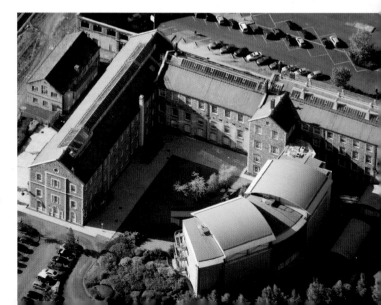

The Historic England offices and archive store in Swindon from the air, 2007.